Creating Radiant
Flowers in
Colored Pencil

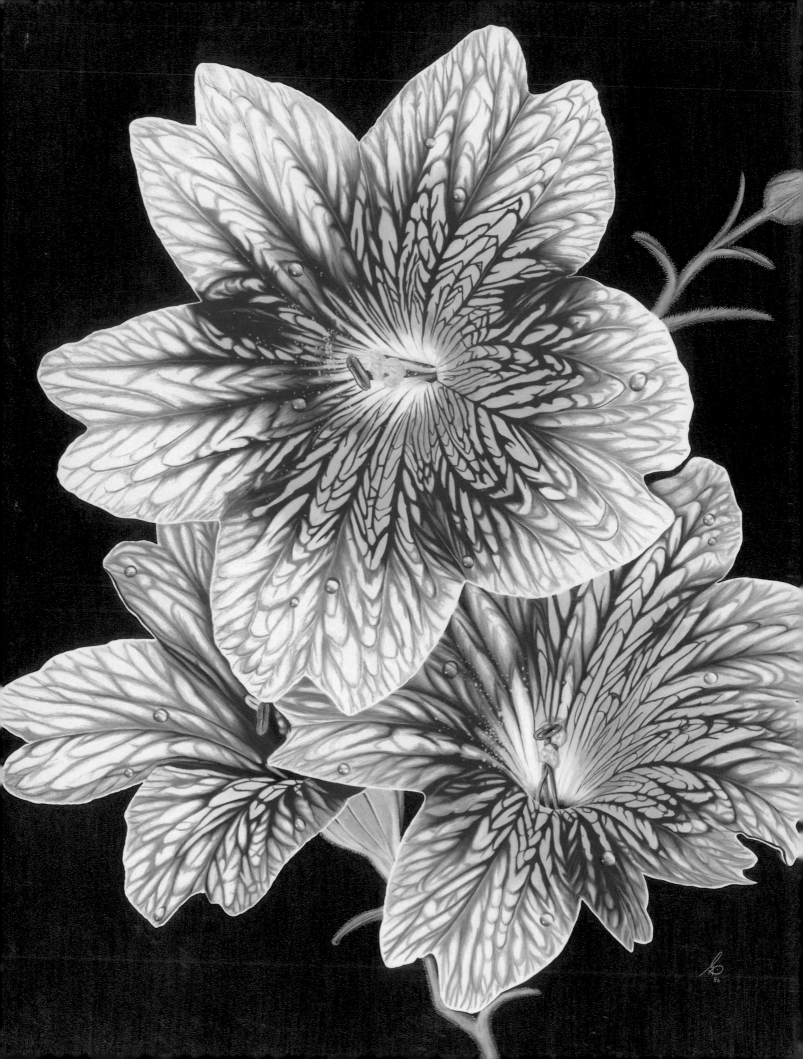

Creating Radiant
Flowers in
Colored Pencil

Gary Greene

NORTH LIGHT BOOKS
Cincinnati, Ohio

ABOUT THE AUTHOR

Gary Greene has a background in technical illustration, graphic design and photography, but since 1983 has been concentrating on his colored-pencil creations. He's won numerous awards. He is the author of *Creating Textures in Colored Pencil*, and his work has been published in *The Complete Colored Pencil Book*, *Best of Colored Pencil* 1 and 2, *American Artist* and *The Artist's Magazine*, among others. He has conducted workshops, demonstrations and lectures throughout the West Coast, teaches colored pencil at the college level, and is a Charter and Signature Member in the Colored Pencil Society of America (CPSA), where he served on the Board of Directors for six years.

Creating Radiant Flowers in Colored Pencil. Copyright © 1997 by Gary Greene. Manufactured in China. All rights reserved. No part of this book may be reproduced in any form or by any electronic or mechanical means including information storage and retrieval systems without permission in writing from the publisher, except by a reviewer, who may quote brief passages in a review. Published by North Light Books, an imprint of F&W Publications, Inc., 1507 Dana Avenue, Cincinnati, Ohio 45207. (800) 289-0963. First edition.

Other fine North Light Books are available from your local bookstore, art supply store or direct from the publisher.

01 00 99 98 97 5 4 3 2 1

North Light Books are available for sales promotions, premiums and fund-raising use. Special editions or book excerpts can also be created to specification. For details, contact: Special Sales Manager, F&W Publications, 1507 Dana Avenue, Cincinnati, Ohio 45207.

Library of Congress Cataloging-in-Publication Data

Greene, Gary.
 Creating radiant flowers in colored pencil / Gary Greene. — 1st ed.
 p. cm.
 Includes index.
 ISBN 0-89134-725-9 (hardcover : alk. paper)
 1. Flowers in art. 2. Colored pencil drawing—Technique.
I. Title.
NC892.G734 1997
743'.7—dc21 96-46793
 CIP

The permissions on page 128 constitute an extension of this copyright page.

Edited by Joyce Dolan and Pamela Seyring
Production edited by Amy Jeynes
Cover design by Angela Lennert Wilcox
Interior design by Angela Lennert Wilcox and Pam Koenig

DEDICATION

to my son, Gregg

a constant source of pride and joy

ACKNOWLEDGMENTS

Thanks to my wife, Patti, who spent many hours alone by the TV and who took on additional responsibilities while I wrote this book. Special thanks to the six contributing artists, Susan Brooks, Edna Henry, Kristy Kutch, Sherry Loomis, Judy McDonald and Terry Sciko, who contributed their time and considerable talent to this project. Thanks again to Rachel Wolf, Pam Seyring, Joyce Dolan, Amy Jeynes, Angela Wilcox, Pam Koenig and everyone at North Light Books, who are first-rate people to work with.

ARTIST'S STATEMENT

Art is, to me, the very essence of life. Because of my main interests in art, namely graphic art, photography and fine art, few moments go by that I'm not thinking art. Once, I was asked what I was going to do when I retired. I rhetorically responded, "Do you think that I'm going to sell my cameras someday and never take another photograph, or give all my colored pencils away and never do another piece of art?" Another remark that I frequently hear (regarding my colored-pencil painting) is, "It must take a lot of patience to do that!" I enjoy working for hours on my colored-pencil paintings!

More significantly, the success of any artist not only depends on his or her talent, but on the support and understanding of loved ones who must allow the artist time and space to create. Thanks, Patti. Thanks, Gregg.

Gary Greene

TABLE OF CONTENTS

FOREWORD

There is a giddy obsessiveness in Gary Greene's colored-pencil renditions. Photo-realistic? No, that would be a rather shoddy compliment. His interpretations have more to do with the interplay of tension and relaxation than with copied flatness.

Gary's work is fascinating. Seeing several of his paintings at a time is mesmerizing. At first glance, our eyes widen, then squint. Foolishly, we try to make sense of the bouncing three-dimensional shapes crashing through what we still believe is a flat drawing surface. But when we let ourselves go, the sensation becomes eerily that of Alice falling into the rabbit hole . . . exhilarating and scary at the same time.

Compelled to stare, we experience a gradual increase of tactile tingling. Between our fingers we actually feel the delicate thinness of a rose petal; our noses twitch at the heady aroma of garden-fresh bell peppers. And, with a shiver, we scrape our fingernails across the grating texture of ship metal lying at anchor. Gradually, our eyes bob with the abstract waves of blue and purple, gold and red . . . and we suddenly begin to know Gary. He loves color and form and texture and what they do to the senses, both his and ours. The more we look at his work, the more we are sure he loves to giggle, laugh and tease.

But as quickly as we get a sense of the artist, his work draws us back to the sensual art of looking. Good art always does that. Gary has the ability to make us discover and fall in love with the greatness in the simplest of objects. His interplay of similar, competing and repetitive textures is an attention grabber. But then, just as quickly, the tension relaxes as we actually hear the lapping of wavelets beneath a sailboard, or feel the various thicknesses of multicolored paint layers peeling from an old set of oars, or smile at the smell of gray metal once covered with slick, glossy car enamel.

Gary's images not only defy the surface, they take us to another world. This new flower book is simply another set of sights and sounds and smells for us to enjoy and learn from.

It is impossible to be neutral about Gary Greene's work—and just as impossible to be neutral about Gary Greene.

Bernard A. Poulin
Author, *The Complete Guide to Colored Pencil*

INTRODUCTION

When my first book, *Creating Textures in Colored Pencil*, was half complete, I approached North Light Books with the idea for writing *Creating Radiant Flowers in Colored Pencil*. My proposal was met with mild enthusiasm until I explained the popularity of flowers as art subjects. Floral paintings constitute approximately one-third of all images I receive from members of the Colored Pencil Society of America (CPSA) for publication in our newsletter. The percentage is the same for entries in the CPSA International Exhibition and the *Best of Colored Pencil* book series (Rockport). With all this interest, why were there no books on painting flowers with colored pencil?

I discovered colored pencil thirteen years ago, when there was only one book on the subject: Bet Borgeson's landmark *The Colored Pencil* (Watson-Guptill). Now there are about two dozen and several more in progress as many artists are abandoning their watercolors, oils, acrylics and pastels and discovering the creative possibilities of colored pencil. You now hold in your hands the first book on how to paint flowers—always a favorite subject—with colored pencil, the hot "new" art medium!

Creating Radiant Flowers in Colored Pencil depicts a variety of flowers in a simple straightforward way, without the visual distractions of backgrounds and containers or the verbal distraction of "artspeak." It's not intended to be a book on botanical illustration, nor is it a "paint by numbers" book. For example, you may want to paint a still life with a certain kind of flower, such as a zinnia. This book will show you how to paint a zinnia, along with sixty-three other flowers. It's up to you to create the subject, composition, style and mood of your painting.

Six talented and highly regarded colored-pencil artists who employ styles and approaches different from my own have graciously contributed three floral illustrations each to *Creating Radiant Flowers in Colored Pencil*. They are Susan Brooks, Edna Henry, Sherry Loomis, Kristy Kutch, Judy McDonald and Terry Sciko. I've duplicated some of the flowers depicted by my colleagues, so you may more closely compare the differences in our styles.

When I first conceived of this book, I thought it would be great fun to do, and it was, even though it was a monumental task requiring over one thousand hours and a year's worth of "art time." My efforts were worthwhile, however, if I can reach artists doing their favorite subject and turn them on to the exciting medium of colored pencil.

Gary Greene

Woodinville, Washington
April, 1996

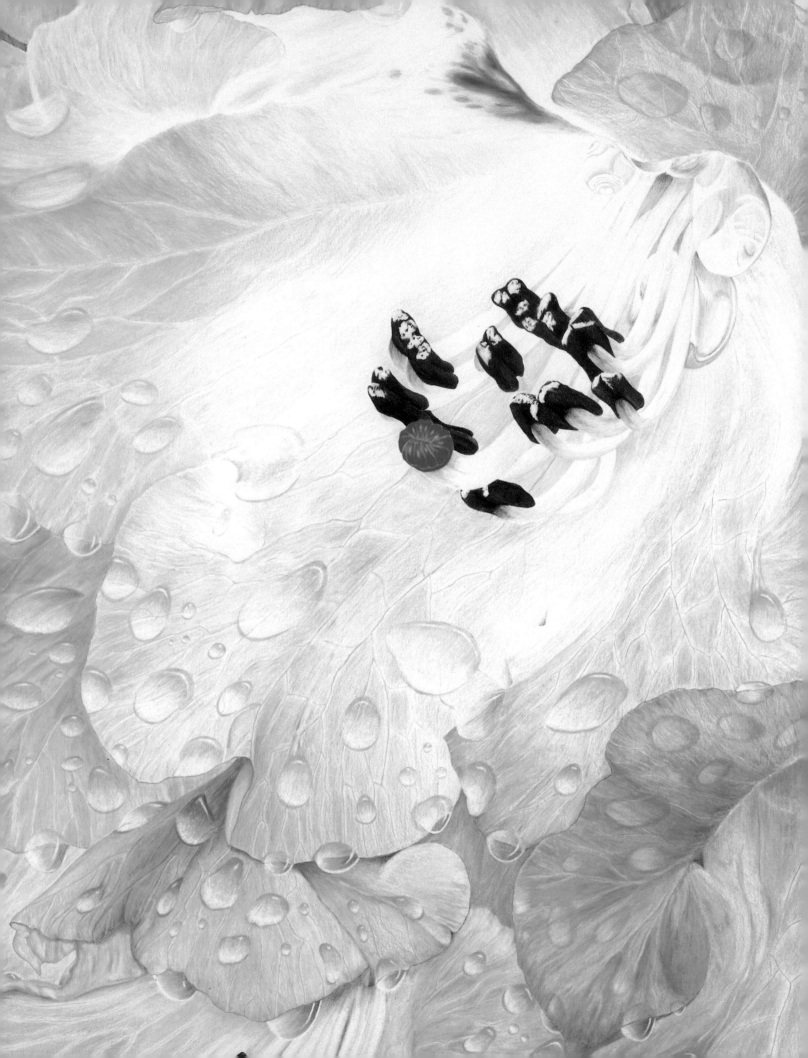

GETTING STARTED

Compared to other mediums, colored-pencil art is inexpensive to create. Consider the cost of high-quality oil, acrylic or watercolor paints, thousand-color sets of pastels (wouldn't it be exciting if colored pencils had that range of colors!), expensive brushes, canvases, easels, and so on. It's easy to see that the basics needed to create colored-pencil art—pencils, paper surface, sharpener, eraser and desk brush—are a bargain. Some tools and related materials discussed here are necessary; some will make your painting easier, but are not essential; and others may be a luxury, suited for the professional. Decide what you need according to your own comfort level and budget.

Colored Pencils

There are three types of colored pencils: wax-based, oil-based and water-soluble. The pigment in wax-based pencils is bound with wax; in oil-based pencils it's bound with vegetable oil. Wax- and oil-based pencils are similar in almost every respect except that oil-based pencils do not exhibit "wax bloom," a filmy residue or glaze which may appear over heavily applied layers of pigment. Wax bloom is caused by wax rising to the surface.

Water-soluble pencils are usually drier and harder than wax or oil pencils. They don't lend themselves as well to heavy applications of pigment used in techniques such as burnishing. All three types of colored pencil can be used together.

Wax Pencils

Wax-based is the most common colored pencil. Primary brands are Prismacolor, Design Spectracolor, and Derwent Studio and Artists series pencils.

Prismacolor pencils are, by far, the most popular colored pencils, primarily because they're most readily available. They have a range of 120 colors and excellent application characteristics, having the softest leads of all brands. Three sets of Grey—Cool Grey, Warm Grey and French Grey, intelligently graduated from 10% to 50%, 70% and 90%—are unrivaled. Most Prismacolor pencils have good lightfastness. One drawback (no pun intended) is Prismacolor's tendency to break and crumble.

Design Spectracolor pencils have a range of 96 colors and are superior to Prismacolors in quality but are more difficult to find individually in open stock. Like Prismacolors, they are very soft and work well with any technique. Design

Spectracolor pencils have done well in lightfastness tests.

Derwent makes two lines (again, no pun intended) of wax-based colored pencils: the Studio and Artists series. Studio pencils have thicker, softer leads than the Artists series. Studio pencils have round casings versus hexagonal Artists series casings. Both series' leads are hard compared to other wax or oil colored pencils, which makes them difficult to use for burnishing. They have superior capabilities, however, for layering, because the point wears down less quickly. Derwent Studio pencils have a range of 120 colors, and the Artists pencils are available in 72 colors. Derwent pencils have superior lightfastness.

Verithin pencils, manufactured by Sanford, are useful for layouts and cleaning up rough edges left when using soft pencils on a toothy surface. Verithins have thin, hard leads coordinated to 36 of Prismacolor's 120 colors.

Art Stix, also made by Sanford, are colored pencils in stick form. Use them to cover large areas and to create loose, bold strokes. Art Stix are available in 48 colors coordinated to the Prismacolor line.

Oil Pencils

Relative newcomers, oil-based colored pencils work exactly like their wax counterparts and mix easily with them. Oil-based pencils are available in two major brands: Lyra Rembrandt Polycolor and Caran D'Ache Pablo pencils.

Polycolor pencils, manufactured in Germany, have a 72-color range. They are soft, although some colors are harder than wax pencils but not hard enough to make them less desirable for heavy applications. Polycolor pencils are of supe-

rior quality, having very little breakage and lightfast colors.

Made in Switzerland, Caran D'Ache Pablo pencils are available in 120 colors. They are somewhat difficult to find and are more expensive than other brands, but Pablos are worth the extra price. The colors are rich, and the leads are soft and of the highest quality.

Water-Soluble (Watercolor)

As the name implies, the pigment in water-soluble pencils dissolves with water, making them versatile. Major brands include Derwent Watercolour, Design Watercolor, Lyra Rembrandt Aquarelle and Caran D'Ache Supracolor.

Derwent Watercolour pencils have a range of 72 colors that match Studio and Artists series wax pencils. They are dry and hard. They don't burnish well, but are excellent for layering and working with water.

Design Watercolor pencils complement 48 colors of the Spectracolor line. Because they are soft, they apply like their waxy counterparts. Although difficult to find, they are well worth the effort in searching for them.

Lyra Aquarelle pencils are water-soluble versions of the oil-based Polycolor pencil line and are available in 72 colors. The colors are vibrant when washed with water. Their soft leads burnish like dry pencils.

With a range of 120 colors, Caran D'Ache Supracolor pencils have the widest range of water-soluble pencils. Mated to the Pablo line, they are the softest water-soluble pencil available, which enhances their versatility. Supracolor pencil quality is truly "supra."

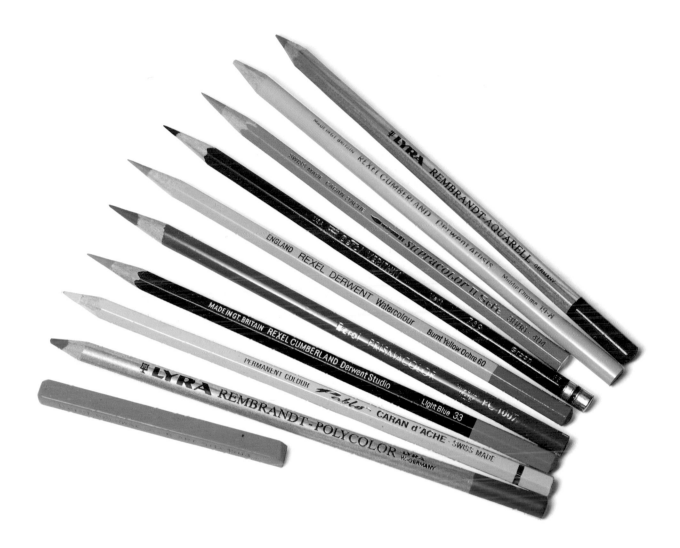

Colored Pencil Comparison Chart

Pencil Type	Brand	Color Range
Soft Wax	Sanford Prismacolor	120
Hard Wax	Rexel Derwent Artists	72
Soft Wax	Design Spectracolor	96
Soft Wax	Rexel Derwent Studio	120
Hard Wax	Sanford Verithin	36
Wax Stick	Sanford Prismacolor Art Stix	48
Oil-Based	Caran D'Ache Pablo	120
Oil-Based	Lyra Rembrandt Polycolor	72
Water Soluble	Caran D'Ache Supracolor II	120
Water Soluble	Rexel Derwent Watercolour	72
Water Soluble	Lyra Rembrandt Aquarelle	72
Water Soluble	Design Watercolor	48

Surfaces

Colored pencil can be painted on a variety of surfaces including wood, cloth, canvas, gesso, drafting film, scratch board and even paper. This array of surface choices enables colored-pencil artists to be creative and innovative.

Other paper surfaces used by the contributing artists in this book:

Susan Brooks	Strathmore 2-ply Museum Board
Edna Henry	Rising Museum Board
Kristy Kutch	Rising 2-ply Museum Board
Sherry Loomis	Strathmore 500 Series Bristol 4-ply, Plate Finish
Judy McDonald	Rising Stonehenge
Terry Sciko	Various tinted papers

Smooth Versus Rough

Smooth surfaces, cold-press boards and papers with a plate finish are good for techniques like simple layering (see page 22) or underpainting (see page 26). They are not suited for techniques requiring heavy applications of pigment, such as burnishing (see page 24), because the pigment doesn't have anything to "grab onto." Burnishing colored pencil on smooth surfaces will result in pigment merely moving around on the surface.

A paper surface that has texture or tooth, such as hot-press board and vellum-finish papers, enables the colored-pencil pigment to anchor in the surface's valleys. A textured paper will allow more layers of pigment on its surface, provide more versatility in color rendition and allow you to paint more detail. When underpainting and layering on a toothy surface, you can create more textures because the valleys don't fill up with pigment. The downside to toothy surfaces is that it often takes longer to finish a painting.

What Paper Should I Use?

Think about how the paper surface will suit the artwork you plan to paint. Also determine if it lends itself to the technique you want to use. You should also like the paper you use. Is it comfortable? Does it feel right? These subjective evaluations are important when choosing a paper surface.

The following are basic points to consider when choosing a paper surface:
• Use acid-free paper; it's always high quality and doesn't deteriorate over time.
• Make sure the surface can withstand erasure and repeated applications of colored pencil, solvent and/or water.
• A paper's color can determine the style of your painting. Remember that colored pencil is a translucent medium, allowing underlying colors to show through.

Some Paper Recommendations

Strathmore 4-ply museum board is an excellent paper surface that meets all of the previously described criteria. It's available in white, black, gray and beige, in 32" x 40" (81cm x 102cm) sheets.

Strathmore 2-ply Bristol Vellum is also an excellent choice. All of the author's illustrations in this book were painted on Strathmore 2-ply Bristol Vellum. Although not as toothy and sturdy as museum board, it still holds up well under heavy use and requires less time to complete a piece of art.

Experiment with different paper textures and colors to find one that best suits you.

Tools

Sharpeners

Manufacturers of electric pencil sharpeners didn't have waxy and oily colored pencils in mind when they designed their products. Electric pencil sharpeners, when used with colored pencils, have short life spans, so stay with inexpensive models! An expensive sharpener won't necessarily last longer. Small battery-operated (cordless) models wear out even more quickly. Limit their use to traveling.

Avoid using a manual sharpener because the frequent, repetitive motion of sharpening pencils may result in carpal tunnel syndrome. In addition, manual sharpening needlessly increases the time it takes to complete a painting.

Erasers

A kneaded eraser is commonly used in colored-pencil work. It's good for light erasing or lifting debris lodged in the paper surface's tooth after heavy application. For heavy-duty erasing, try an imbibed eraser such as a Koh-I-Noor #285. This eraser will quickly remove thick layers of colored pencil without damaging the paper surface. To increase efficiency and open creative avenues, use an imbibed eraser strip in an electric eraser.

Electric Eraser

This tool may not be a necessity, but an electric eraser can make your erasing simpler and cleaner. Look for electric erasers with the most power, and avoid cordless models that will run out of juice at the most inopportune moment.

Pencil Extender

These valuable but somewhat expensive pencil holders allow you to grind your pencil down to a stub limited in length only to the depth of your pencil sharpener. Watch for sales or buy them through mail-order catalogs. A quick tip: Glue your pencil stubs together with instant glue to extend their use.

Bestine (Rubber Cement Thinner)

Bestine is used extensively in this book to depict subtle textures and colors. Although its ingredients are toxic, it is safe if used with a little common sense. Handle in a well-ventilated room, avoid getting the liquid on your skin, and *no smoking*. When using Bestine, pour a minimal amount into a small, narrow-mouth glass jar with a screw-on lid, then dip an applicator into the solvent and immediately cap the jar. This minimizes evaporation and also makes handling this material less hazardous. If you're hypersensitive to solvents, use water-soluble pencils. The effect will be somewhat different but still will have excellent results.

Turpenoid (Odorless Turpentine)

Turpenoid will produce effects similar to washes with water-soluble pencil or Bestine. The differences are that Turpenoid dries more quickly than water, resulting in a more even application of color. Evaporating less quickly than Bestine, Turpenoid produces a splotchier effect. Even though it's odorless, caution should be taken when handling this solvent. The lack of odor doesn't mean that the harmful toxins are missing. Always use adequate ventilation.

Container for Solvent

A small glass container with a narrow neck and a tight-fitting screw-on cap is necessary for storing solvents.

Colorless Blenders or Markers

Colorless blenders are markers without pigment. They are available in a variety of nib sizes and shapes. They produce interesting strokes when applied to colored pencil. They're not recommended for large areas, because they have a tendency to streak—unless that's the effect you're going for. Take care to wipe the applicator thoroughly after using each color, because the residual color on the nib can contaminate the next color with potentially disastrous results. Colorless markers are highly toxic with a particularly strong odor.

More Tools

Brushes

Buying expensive red sable brushes for colored-pencil work is a waste of money! If you have good brushes, use them for water, but never use them with Bestine unless you're independently wealthy. In time, solvents will dissolve the glue that holds the bristles together.

Dry Applicators

You can apply solvent with a variety of materials. Use cotton swabs, cotton balls, rags, even cheesecloth. Use swabs with long, wooden applicators, available at hospital supply stores. Long-handled swabs are better quality and prevent solvent from getting on your fingers.

Graphite Pencil

Use a 3B pencil for preliminary layouts.

Desk Brush

Sometimes called a foxtail brush, a desk brush helps to keep your art free of debris. Many artists use a large paintbrush or other inexpensive devices, and some "pros" use canned air instead of a brush.

X-Acto Knife

Use a #16 chisel-edge blade to scrape away applications of colored pencil to create textures. A #11 pointed blade should be used only for small areas or to etch thin lines.

Sandpaper

Use a fine grade of sandpaper to sharpen electric eraser strips and/or dull pencil points.

Erasing Shield

An erasing shield is a thin, flat piece of aluminum with assorted openings. It allows you to erase tight areas.

Container for Water

Keep the container small. Water-soluble pencils do not require large amounts of liquid.

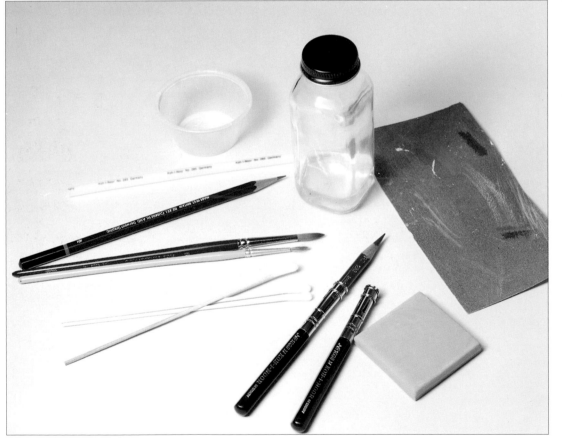

Typical colored-pencil tools: container for water, container for solvent, sandpaper, kneaded eraser, pencil extenders, cotton swabs, brushes, graphite pencil, imbibed eraser strip.

Master Color List

The following charts show the colors used for the illustrations in this book. All colors listed in the color palettes at the beginning of each project are Prismacolor brand unless otherwise noted. The following abbreviations are used:

(Verithin)	Prismacolor Verithin
(Lyra)	Lyra Rembrandt Polycolor
(Spectracolor)	Design Spectracolor
(Pablo)	Caran D'Ache Pablo
(Derwent WS)	Rexel Derwent Watercolour
(Derwent Artists)	Rexel Derwent Artists
(Supracolor)	Caran D'Ache Supracolor II

Rexel Derwent Watercolour

Blue Violet Lake	Magenta	
Bottle Green	May Green	
Burnt Umber	Middle Chrome	
Cedar Green	Olive Green	
Deep Cadmium	Pink Madder Lake	
Delft Blue	Primrose Yellow	
Emerald Green	Raw Sienna	
Imperial Purple	Rose Madder Lake	
Jade Green	Rose Pink	
Kingfisher Blue	Smalt Blue	
Light Blue	Spectrum Blue	
Light Violet	Spectrum Orange	
	Straw Yellow	
	Terracotta	

Lyra Rembrandt Polycolor

Apple Green	Light Ochre	
Aquamarine	Light Orange	
Burnt Ochre	Light Violet	
Canary Yellow	Magenta	
Cedar Green	Moss Green	
Cinnamon	Olive Green	
Cream	Oriental Blue	
Dark Carmine	Pale Geranium Lake	
Dark Flesh	Peacock Blue	
Dark Orange	Pink Madder Lake	
Emerald Green	Pompeian Red	
Grey Green	Red Violet	
Hooker's Green	Rose Carmine	
Indian Red	Rose Madder Lake	
Juniper Green	Sap Green	
Light Blue	Scarlet Lake	
Light Carmine	Sea Green	
Light Chrome	Vermillion	
Light Flesh	Violet	
Light Green	Wine Red	
	Zinc Yellow	

Master Color List

Sanford Prismacolor

Apple Green		Crimson Red		Lavender		Rosy Beige	
Aquamarine		Dahlia Purple		Light Aqua		Salmon Pink	
Black		Dark Green		Light Green		Scarlet Lake	
Black Grape		Dark Purple		Light Umber		Sepia	
Blue Slate		Dark Umber		Lilac		Sienna Brown	
Blush		Deco Orange		Limepeel		Spanish Orange	
Blush Pink		Deco Peach		Magenta		Spring Green	
Bronze		Deco Pink		Mineral Orange		Sunburst Yellow	
Burnt Ochre		Deco Yellow		Mulberry		Terra Cotta	
Canary Yellow		French Grey 10%		Olive Green		True Blue	
Carmine Red		French Grey 20%		Orange		True Green	
Celadon Green		French Grey 30%		Pale Vermilion		Tuscan Red	
Chartreuse		French Grey 50%		Parma Violet		Violet	
Clay Rose		French Grey 70%		Parrot Green		Violet Blue	
Cloud Blue		French Grey 90%		Peacock Green		Warm Grey 70%	
Cool Grey 10%		Goldenrod		Periwinkle		Warm Grey 90%	
Cool Grey 20%		Grass Green		Pink		White	
Cool Grey 30%		Greyed Lavender		Pink Rose		Yellow Ochre	
Cool Grey 50%		Henna		Poppy Red		Yellow Chartreuse	
Cool Grey 70%		Hot Pink		Process Red		Yellowed Orange	
Cool Grey 90%		Imperial Violet		Pumpkin Orange			
Cream		Indigo Blue		Purple			
		Jasmine		Raspberry			

Design Spectracolor

Canary Yellow

Carmine Red

Crimson Lake

Deep Violet

Lavender

Real Green

Slate Grey

Caran D'Ache Pablo

Green Ochre

Hazel

Olive Black

Olive Yellow

Pale Yellow

Caran D'Ache Supracolor II

Brownish Beige

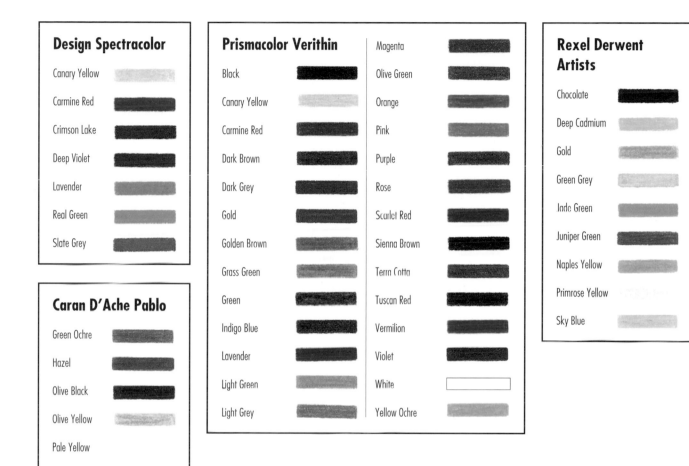

Prismacolor Verithin

Black

Canary Yellow

Carmine Red

Dark Brown

Dark Grey

Gold

Golden Brown

Grass Green

Green

Indigo Blue

Lavender

Light Green

Light Grey

Magenta

Olive Green

Orange

Pink

Purple

Rose

Scarlet Red

Sienna Brown

Terra Cotta

Tuscan Red

Vermilion

Violet

White

Yellow Ochre

Rexel Derwent Artists

Chocolate

Deep Cadmium

Gold

Green Grey

Jade Green

Juniper Green

Naples Yellow

Primrose Yellow

Sky Blue

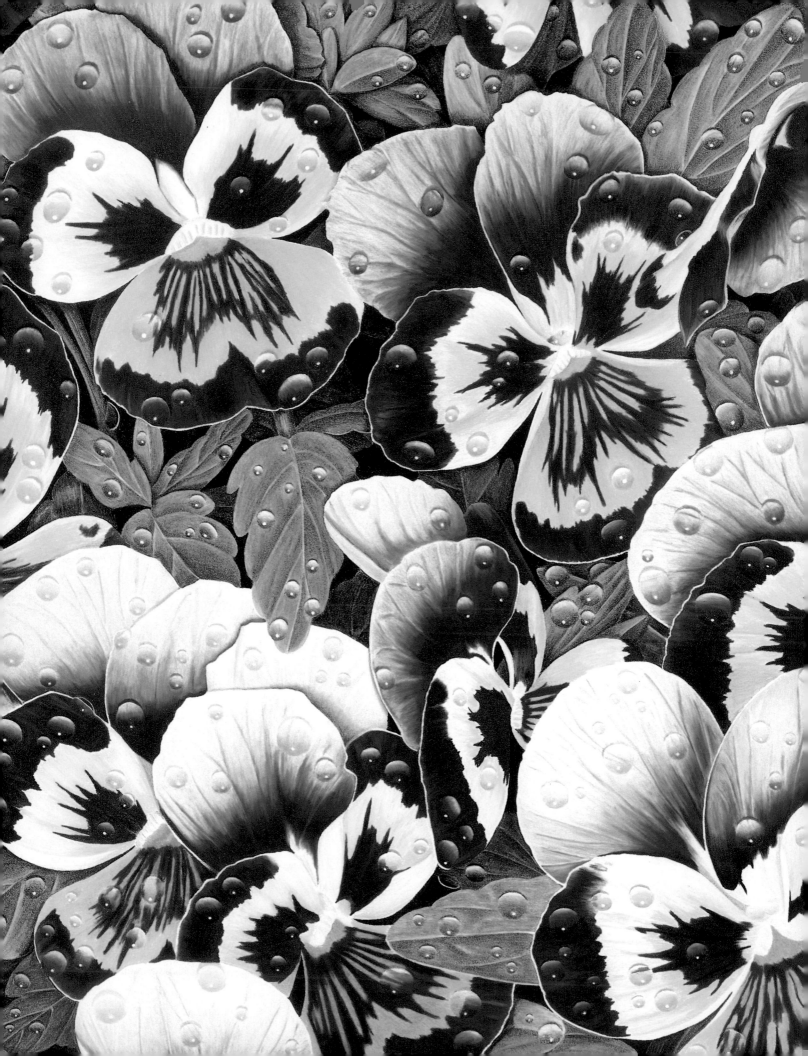

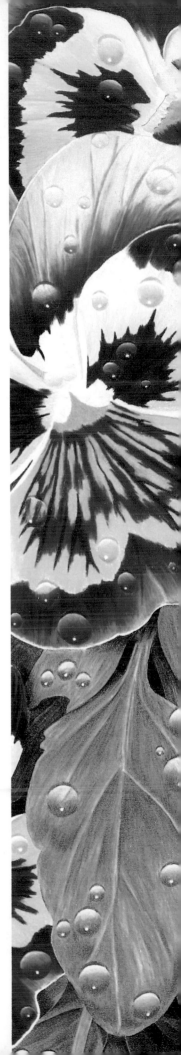

TECHNIQUES & REFERENCES

In this chapter we'll explore the techniques used to create paintings of flowers with colored pencil and how to find and use subject material.

Three techniques employed to create our flowers are layering, burnishing and underpainting. These techniques are usually used in combination, depending on the color, texture or level of detail needed in a flower. This chapter shows you basic demonstrations of these three techniques. After learning the basics, don't be afraid to "break the rules" and try your own variations or, better yet, invent your own technique.

Layering

Layering is a technique employing light applications of color layered on top of each other, allowing the tooth of the paper surface to show through. Paper plays an important role in layering. The appearance, texture and mood of a painting may be manipulated by using surfaces of varying tooth and/or color. Layering is used in the beginning stages of burnishing, applied on top of an underpainting to depict texture or used in combination with both techniques.

When layering, start with the darkest values, using light pressure and small, circular strokes that follow the contours of the object you're painting. In the example on the facing page, start with the lighter color, yellow, to minimize its contamination by the stronger red hue. Create complex hues, values and gradations by adding colors, resulting in wonderfully exciting, luminous and elaborate paintings. Sherry Loomis, one of our contributing artists (pages 104, 106, 110 and 127), is a master of this technique.

COLORED-PENCIL FACTS & TIPS

• Colored pencil, once applied, cannot be completely erased without damage to the paper surface.

• When using graphite or hard colored pencils in layouts, always use light pressure, because you may leave an undesirable impressed line on the painting that will be difficult to cover up, especially when layering.

• Colored pencil is a translucent medium. It's not transparent like watercolor, nor opaque like oil or acrylic; it's somewhere in between. Base colors and values show through layers of color built on top of them.

• Always erase graphite lines used for layouts before applying color, or the graphite will show through due to the translucent quality of colored pencils. It's nearly impossible to erase after color is applied. Use graphite for your rough layouts. Then draw the finished layout lines next to—not on top of—them with colored pencil, preferably Verithin. Remove the graphite with a kneaded eraser. The colored-pencil lines will remain because they can't be completely erased.

• Use a hair dryer to dry water washes to minimize paper buckling.

1 Layer Goldenrod and Sunburst Yellow. Notice I used Scarlet Red (Verithin) for the layout lines.

2 Layer Canary Yellow (Lyra).

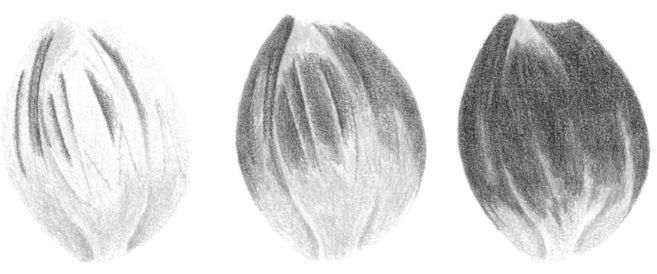

3 Layer Crimson Red.

4 Layer Pale Geranium Lake (Lyra).

5 Layer Poppy Red.

Burnishing

Burnishing involves layering at least two colors, blending them together with a light color, often white, then layering more colors and blending again. This is repeated until the paper surface is entirely covered. Always complete the lighter areas of color first to prevent darker colors from adjacent areas being dragged into lighter areas.

Apply colors lightly at first by layering lighter colors on top of darker colors. Repeat this process until the paper surface is approximately two-thirds covered with pigment but still showing through. Then use a white or very light colored pencil and, with heavy pressure, burnish the layered colors together. Now layer the same colors again over the area just burnished. Repeat layering and burnishing until the paper surface is completely covered with colored-pencil pigment.

You can also burnish with solvents, colorless markers or dry applicators.

The dahlia petal on the facing page demonstrates the burnishing technique.

1 Begin after the last step of the layering technique. Use White to burnish all but the darkest values.

2 Burnish the yellow and into the red area with Canary Yellow (Lyra).

3 Burnish the red area with Crimson Red, Pale Geranium Lake (Lyra) and Poppy Red. Then burnish the entire petal with Canary Yellow (Lyra). Repeat this step until the surface is entirely covered.

COLORED-PENCIL FACTS & TIPS

- Unlike liquid mediums, which are mixed separately on a palette, colored-pencil hues are created by mixing directly on the art as you paint. It's a good idea to plan colors on a separate piece of paper before starting to paint. Never use just one color. Always combine at least two colors to produce more interesting hues.

- If possible, complete the lightest areas of your painting first. This minimizes dragging undesired darker colors into the light areas.

- Clean up ragged edges with a hard lead colored pencil.

- Sharp pencil points yield intense color but cover a smaller area. The effect is reversed as the point becomes dull.

- Keep art free of debris left by the pencil as you work. If debris gets lodged in the paper's tooth, it can cause contamination of color.

- When using Bestine with a cotton swab, discard the swab after each pass. Do not dip it back into the Bestine.

- If using white paper, leave it free of pigment for sparkling highlights.

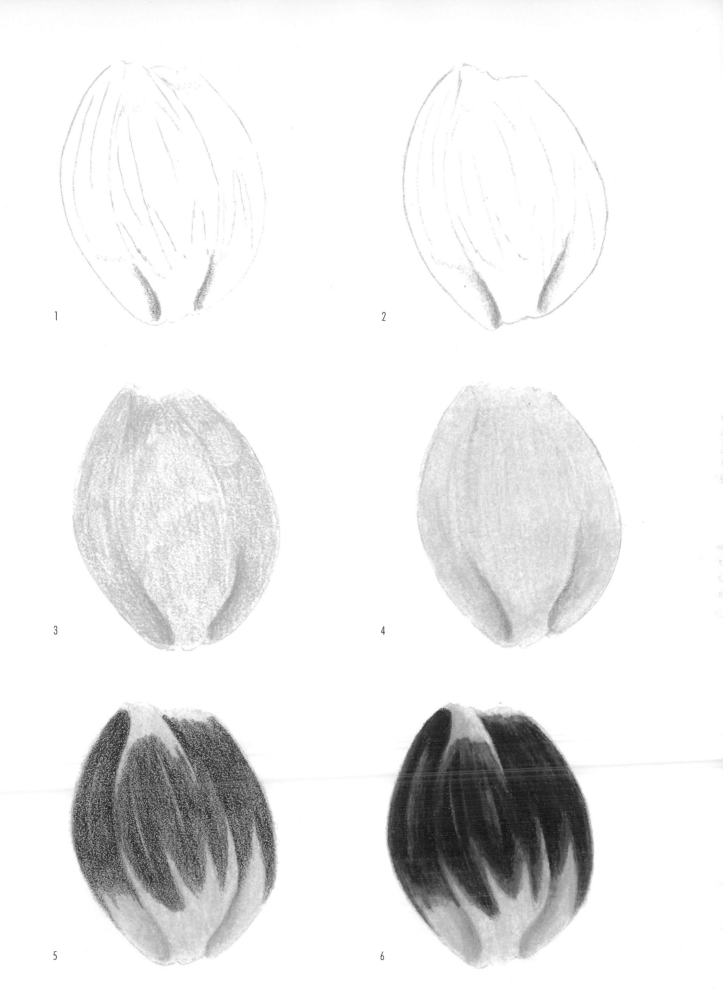

References

Flowers are everywhere, so obtaining good reference material should be easy. Wrong! To truly capture flowers in colored pencil, or any medium, you need to observe and understand their structure. This enables you to know which details to include and which to omit. No matter what style you use, whether it's realistic, stylized or abstract, you need excellent reference material to produce excellent flower paintings.

Because colored-pencil paintings require more time to complete than most mediums, perishable items like flowers, especially cut flowers, may wither and die long before you finish your painting. The solution to this problem is to work from photographs.

Camera Equipment

Ideally, you should work from your own reference material, which makes it important to have at least a working familiarity with photography. The better you are at taking photographs, the better your artwork will be. Use a 35mm camera that has interchangeable lenses (not a "point and shoot" lens), a tripod and an electronic flash.

Lens

The best lens for taking photos of flowers is a macro lens with a focal length of 100mm. Some zoom lenses have so-called close focus settings but are not true macro lenses. Macro lenses are expensive, so if one isn't in your budget, or you're just starting out in photography, close-up (diopter) filters are an inexpensive substitute. They aren't as sharp, however, as a macro lens.

Film

I recommend you use slide transparency film when shooting flowers or for any reference photography. Slide film produces sharper images with truer color than prints because slides are first generation. Prints, because they're printed from a negative, are second generation. A slide's color reproduction isn't subject to the inaccuracy of mechanically produced prints.

Unrivaled for sharpness and rich color is Fujichrome Velvia, with a speed of 50. Other good slide films for photographing flowers are Kodak Lumiere and Fujichrome Provia, both 100 speed. Many labs can process these films in two hours or less. Kodachrome 25 and 64 speeds are also excellent slide films, but must be sent out for processing, taking one to two weeks.

Tripod

Use the smallest f-stop setting on your lens, especially with a macro lens, so everything can be in sharp focus. A small f-stop setting, combined with a slow-speed film, will require a tripod. To make life easier, I recommend a tripod mount with a quick release and a ball head. A quick release has a plate that screws into the bottom of your camera and snaps onto the tripod. This eliminates screwing your camera onto the tripod. The ball head eliminates loosening and tightening clumsy levers. Instead, you can position the camera any way you want, because it's on a ball and socket.

Viewing the Slides

To view slides when working on your art, insert the slide into a clear plastic sleeve, then tape it to an inexpensive (about twelve dollars) photographic loupe. Use a desk lamp with a full-spectrum tube or bulb for lighting. If this seems like a strange way of working, compare a slide and a print of the same subject and see for yourself which is better. A majority of the illustrations in this book were created using this method.

Other References

Many artists seem averse to photography, but I think it's the most important tool in producing excellent art. Besides the obvious reasons, photography gives you the ability to really see the subject firsthand.

If, for whatever reason, you still wish to avoid photography, there are many reference materials available for painting flowers: books and magazines on gardening, seed catalogs and seed packages. The sharpness or accuracy of color in these printed images will never equal slides you photograph yourself, however.

It's OK to copy someone's photographs for practice and to hang the paintings in your living room, but remember: If you copy a photograph from another source, you must change the image enough so it won't be recognizable if you plan to exhibit or sell your painting. You may be in violation of copyright laws if you don't.

Colored-Pencil Paintings and Their Reference Photos

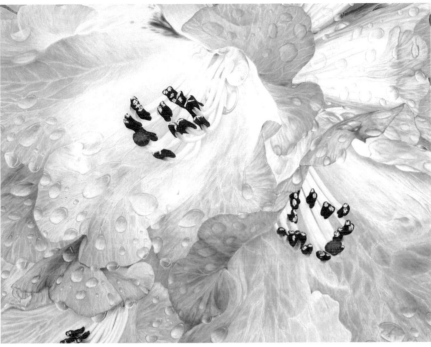

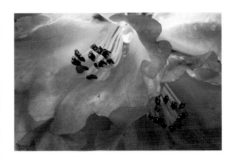

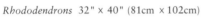

Rhododendrons 32" x 40" (81cm x 102cm)

Flower Power 2 27" x 38" (69cm x 97cm)

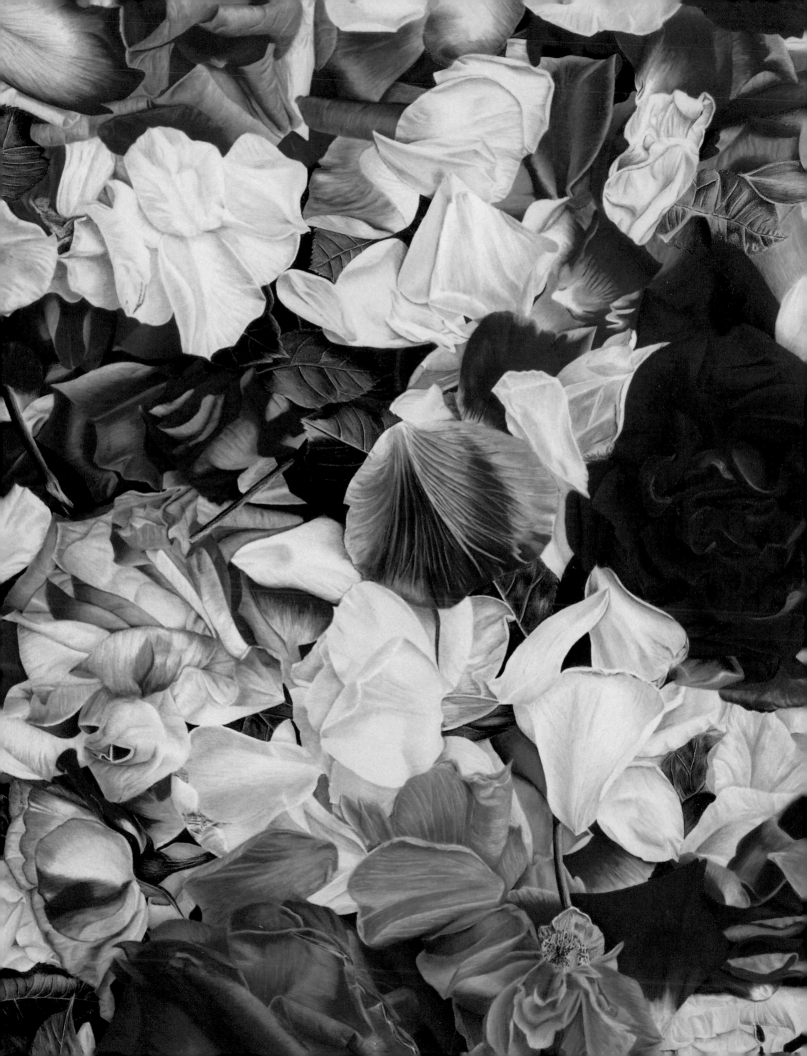

A PLETHORA OF FLORA

And now—the flowers! The rest of this book is devoted to demonstrations of how to paint different types of flowers with colored pencil.

A variety of flowers are represented. Some are common garden flowers, such as roses, irises, pansies and tulips, that are painted and drawn so often they may seem trite. But, after learning the basics, think about painting these usual flowers in unusual ways. Remember, a rose is a rose is a rose . . .

I've also selected flowers I find unusual because of their interesting color, texture, shape or lack of respect. Cacti, tropical flowers and wildflowers—they're all here.

In order to make the instructions as clear as possible to most people, I've not used strict botanical terms in defining the parts of the flowers.

Let's begin!

Azalea

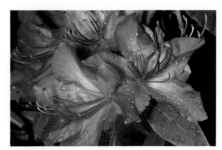

Reference photo

Color Palette

Lavender (Verithin)
Black Grape
Violet
Parma Violet
Lilac
Lavender
Lavender (Spectracolor)
White
Violet (Verithin)
Light Umber
Dark Brown (Verithin)
Burnt Ochre (Lyra)
Golden Brown (Verithin)
Cream
Purple (Verithin)
Magenta (Verithin)
Cool Grey 90%
Cool Grey 50%
Cool Grey 10%
Juniper Green (Lyra)
Olive Green
Limepeel
Olive Green (Verithin)

Petals

1 Indicate veins with Lavender (Verithin). Layer dark values with Black Grape, Violet. Layer Parma Violet, Lilac, Lavender, Lavender (Spectracolor). Leave a line free of color parallel to lavender vein line.

2 Wash with Bestine and a highly saturated medium brush.

3 Lightly burnish with White, dragging color in to highlight vein line.

4 Lightly burnish with Parma Violet, Lilac, Lavender, Lavender (Spectracolor). Repeat steps 3 and 4 as necessary. Sharpen edges with Lavender or Violet (Verithin).

5 Lightly burnish spots at center with Light Umber.

Pistils

6 Layer darkest values with Dark Brown (Verithin). Layer Burnt Ochre (Lyra), Golden Brown (Verithin). Lightly burnish with Cream.

7 Layer Purple (Verithin), Magenta (Verithin). Lightly burnish dark values with Cool Grey 50%, light values with Cool Grey 10%, White. Burnish with Purple (Verithin), Magenta (Verithin).

Leaves

8 Lightly burnish with Cream. Wash with Bestine and a cotton swab.

9 Randomly layer shadows with Cool Grey 90%. Layer Juniper Green (Lyra), Olive Green, Limepeel, leaving some Cream underpainting showing.

10 Wash with Bestine and a highly saturated medium brush.

11 Lightly burnish with Juniper Green (Lyra), Olive Green, Limepeel. Dab with Bestine and a small brush. Repeat burnishing as necessary. Sharpen edges with Olive Green (Verithin).

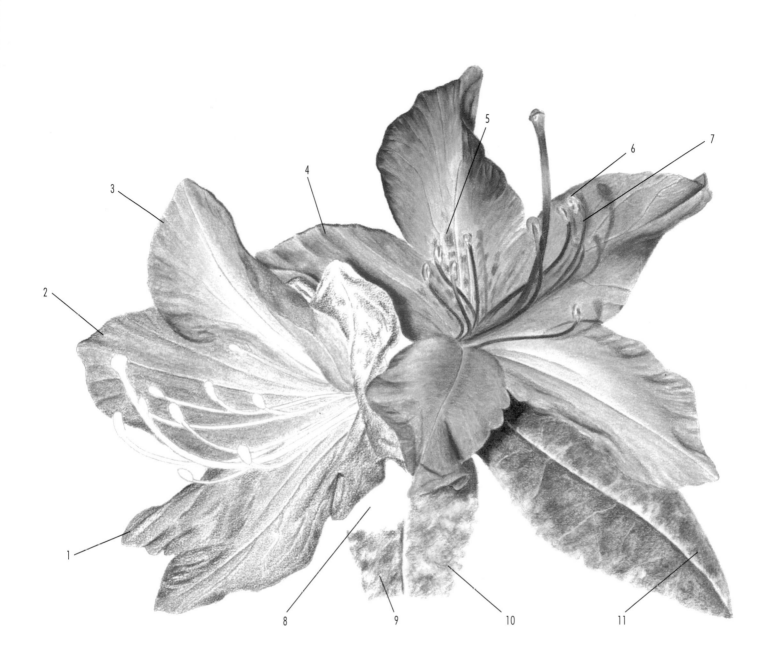

3

4

5

7

6

2

1

8

9

10

11

Anthurium

Reference photo

Color Palette

French Grey 10%
French Grey 20%
French Grey 30%
French Grey 50%
Light Grey (Verithin)
Goldenrod
Canary Yellow (Lyra)
Yellow Ochre (Verithin)
Tuscan Red
Crimson Lake (Spectracolor)
Crimson Red
Scarlet Lake
Poppy Red
White
Cool Grey 90%
Olive Black (Pablo)
Grass Green
Olive Green
Limepeel
Cream

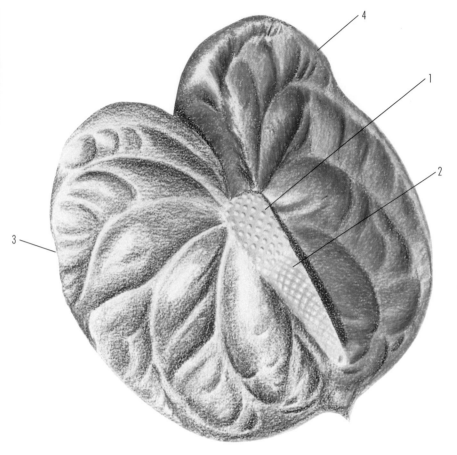

Center

1 Layer French Grey 50%, 30%, 20%. Leave "bumps" free of color. Burnish with French Grey 10%. Indicate shadow on one side of bumps with Light Grey (Verithin).

2 Define pattern by burnishing with Goldenrod. Burnish with Canary Yellow (Lyra). Dab with Bestine and a small brush. Redefine pattern with Yellow Ochre (Verithin).

Petal

3 Layer darkest values with Tuscan Red. Layer Crimson Lake (Spectracolor), Crimson Red, Scarlet Lake, Poppy Red, leaving highlight areas free of color.

4 Burnish with White.

5 See opposite page. Burnish darkest values with Crimson Lake (Spectracolor). Burnish with Crimson Red, Scarlet Lake, Poppy Red, leaving highlight areas free of color.

Leaves

6 Layer darkest values with Cool Grey 90%. Layer Olive Black (Pablo), Grass Green, Olive Green, leaving highlight areas free of color. Burnish with Limepeel, Cream. Burnish dark values with Olive Black (Pablo), Olive Green. Repeat burnishing with Limepeel and Cream as required.

Amaryllis

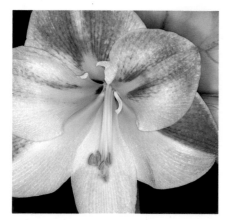

Reference photo

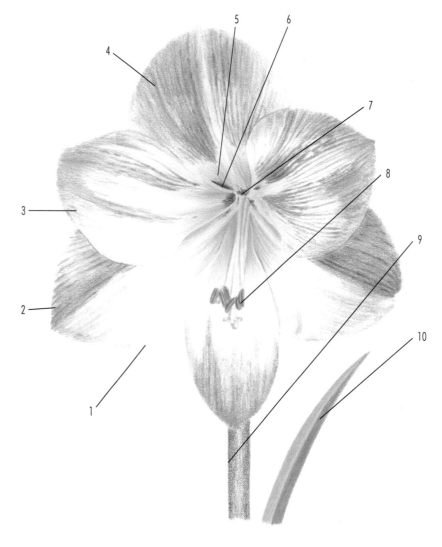

Color Palette

Cool Grey 50%
Cool Grey 20%
Cool Grey 10%
Blush
Pink
Rose Madder Lake (Lyra)
Process Red
Apple Green
Spring Green
Chartreuse
Yellow Chartreuse
Cream
Light Green (Verithin)
Dark Green
Henna
Golden Brown (Verithin)
Yellow Ochre (Verithin)
Grass Green
Olive Green
Olive Green (Verithin)

Petal

1 Layer darkest values with Cool Grey 20%. Layer Cool Grey 10%. Then wash with Bestine and a medium-small brush.

2 Layer Blush, Pink.

3 Smudge lighter areas of petal with a dry cotton swab. Wash with Bestine and a medium-small brush.

4 Layer Rose Madder Lake (Lyra), Process Red. Dab with Bestine and a small brush.

5 Layer Apple Green, Spring Green, Chartreuse, Yellow Chartreuse. Layer the area between pistils with Cream. Then smudge lighter areas of petal with dry cotton swab. Add variegations with Light Green (Verithin). Dab with Bestine and a small brush.

6 Layer Cool Grey 50%, then burnish a small area in center with Dark Green.

7 Layer green area with Henna. Dab with Bestine and a small brush.

8 Layer Golden Brown (Verithin). Burnish pistil tips with Yellow Ochre (Verithin).

Stem and Leaves

9 Layer Grass Green, Olive Green.

10 Burnish with Cool Grey 10%. Sharpen edges with Olive Green (Verithin).

Aster

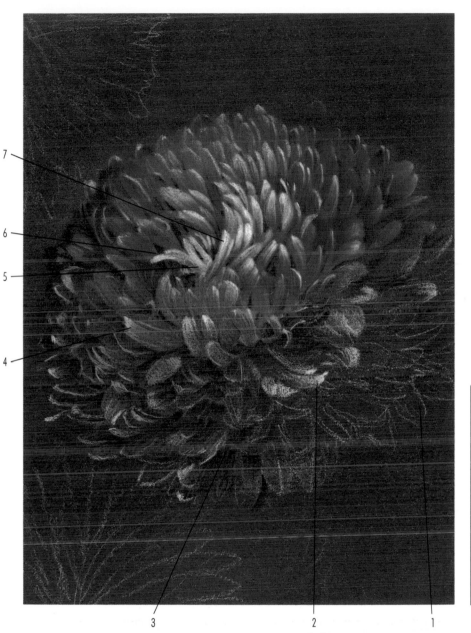

1 Lay out with White.

2 Layer highlights with White.

3 Layer shadows with Imperial Violet, Black Grape.

4 Layer Lavender, Lilac. Burnish with cheesecloth. Then layer with Greyed Lavender. Repeat steps 2 and 3.

5 Layer center petals with Yellowed Orange. Burnish with White.

6 Lightly layer base of petals with Hot Pink. Lightly burnish with Greyed Lavender.

7 Burnish center petals with Cream.

Color Palette
Crescent mat board, Williamsburg Green

White
Imperial Violet
Black Grape
Lavender
Lilac
Greyed Lavender
Yellowed Orange
Hot Pink
Cream

Begonia

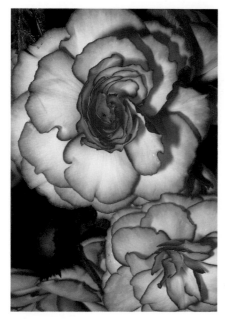

Reference photo

Color Palette

Cool Grey 10%
Cool Grey 30%
Spanish Orange
Sunburst Yellow
Crimson Red
Magenta
Carmine Red
White
Carmine Red (Verithin)
French Grey 10%
French Grey 50%
French Grey 90%
Tuscan Red
Terra Cotta
Juniper Green (Lyra)
Olive Green
Cream
Terra Cotta (Verithin)

Petals

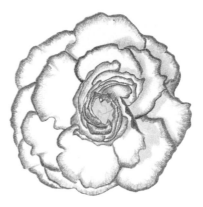

1 Layer Cool Grey 30% in shadow areas. Wash with Bestine and a cotton swab. Layer Spanish Orange, Sunburst Yellow in center. Wash with Bestine and a cotton swab.

2 Lightly layer Crimson Red, Magenta, Carmine Red to edges of petals, using short perpendicular strokes. Layer Cool Grey 30% in shadow areas. Layer folds with Cool Grey 10%.

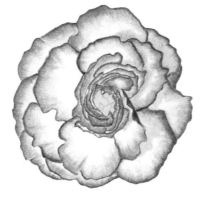

3 Carefully wash petals with Bestine and a cotton swab, using strokes perpendicular to the edge of the petal, dragging the nearly dry cotton swab toward the center of the flower.

4 Burnish shadow areas with White or Cool Grey 10%. Sharpen edges with Carmine Red (Verithin). Layer shadow areas at center with French Grey 50%. Burnish with Spanish Orange, Sunburst Yellow. Burnish shadow areas with French Grey 10%.

Leaves

5 Layer shadows with Tuscan Red. Layer edge of leaf with Terra Cotta, Magenta.

6 Layer random shadows with French Grey 90%.

7 Randomly layer Juniper Green (Lyra), Olive Green, leaving highlights free of color.

8 Lightly burnish lighter values with Cream, darker values with Juniper Green (Lyra) and Olive Green. Sharpen edges with Terra Cotta (Verithin).

Bird of Paradise

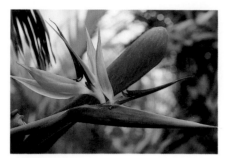

Reference photo

Orange Petals

1 Layer Pumpkin Orange, Pale Vermilion, Dark Orange (Lyra), Orange. Layer lower portion with French Grey 10%.

2 Burnish lower portion with Cream.

3 Lightly burnish with Pale Vermilion, Dark Orange (Lyra), Orange.

4 Burnish all but the lower portion with White.

5 Burnish with Pale Vermilion, Dark Orange (Lyra), Orange, Spanish Orange. Sharpen edges with Orange (Verithin).

Violet Petals

6 Layer Black Grape, Violet.

7 Burnish with White.

8 Burnish Black Grape, Violet. Burnish lighter areas with White. Sharpen edges with Violet (Verithin).

9 Burnish end of petal with Light Umber as shown on the opposite page, dragging violet into area.

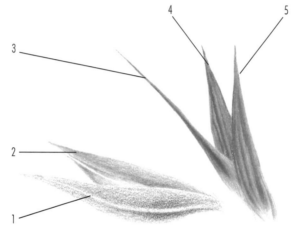

Base and Stem

10 Layer darkest values in both orange and green areas with French Grey 50%. Wash with Bestine and a cotton swab. Then layer French Grey 20%, Pumpkin Orange, Pale Vermilion, Dark Orange (Lyra), Orange. Wash with Bestine and a cotton swab. Repeat layering the last sequence of colors and washing as necessary.

11 Layer Dark Green, Olive Green, French Grey 20%. Wash with Bestine and a cotton swab, dragging color into orange areas. Lightly burnish Dark Green, Olive Green, French Grey 20%. Repeat layering, washing and dragging as necessary. Sharpen edges with Olive Green (Verithin) and Orange (Verithin).

Cactus Flower

Color Palette

- Deco Yellow
- Jasmine
- Sunburst Yellow
- Goldenrod
- Yellow Ochre
- Pumpkin Orange
- Crimson Red
- Scarlet Lake
- Poppy Red
- Pale Geranium Lake (Lyra)
- Orange (Verithin)
- Scarlet Red (Verithin)
- Process Red
- Magenta
- Rose Madder Lake (Lyra)
- Black Grape
- Violet
- Dahlia Purple
- Mulberry
- Parma Violet
- Lilac
- Lavender
- Greyed Lavender
- Cool Grey 50%
- Cool Grey 20%
- White
- Rose (Verithin)
- Lavender (Verithin)
- White (Verithin)
- Warm Grey 90%
- Cedar Green (Lyra)
- Olive Black (Pablo)
- Olive Green
- Limepeel
- Olive Green (Verithin)
- Indian Red (Lyra)
- Magenta (Verithin)
- Light Grey (Verithin)
- Light Green (Verithin)

Center

1 Layer upper center with Deco Yellow, Jasmine. Wash with Bestine and a cotton swab. Layer lower center with Sunburst Yellow. Wash with Bestine and a cotton swab.

2 Burnish upper center with Goldenrod, Yellow Ochre. Randomly erase small areas with sharpened imbibed eraser strip and electric eraser. Dab with Bestine and a cotton swab.

3 Layer Pumpkin Orange, Crimson Red, Scarlet Lake, Poppy Red, Pale Geranium Lake (Lyra), Process Red. Burnish with Orange (Verithin).

4 Layer Crimson Red, Poppy Red. Burnish with Pale Geranium Lake (Lyra). Sharpen edges with Scarlet Red (Verithin).

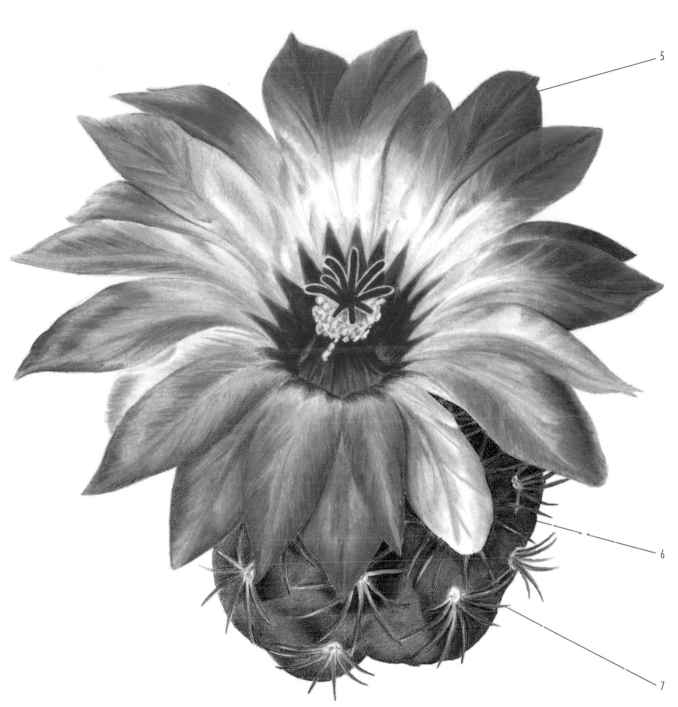

Petals

Note: Color palette varies from petal to petal; individual petals do not have all the colors listed in step 5.

5 Layer Process Red, Magenta, Rose Madder Lake (Lyra), Black Grape, Violet, Dahlia Purple, Mulberry, Parma Violet, Lilac, Lavender, Greyed Lavender, Cool Grey 50%, 20%. Burnish with White. Repeat this entire step as necessary. Sharpen edges with Rose (Verithin), Lavender (Verithin) or White (Verithin).

Cactus Barrel

6 Layer dark values with Warm Grey 90%. Layer Cedar Green (Lyra), Olive Black (Pablo), Olive Green, leaving spines free of color. Burnish dark values with Olive Green. Burnish light values with Limepeel. Sharpen edges with Olive Green (Verithin).

Spines

7 Randomly layer Indian Red (Lyra), Magenta (Verithin). Burnish dark areas with Light Grey (Verithin). Burnish light areas with White (Verithin). Repeat step as necessary. Sharpen inside areas with Olive Green (Verithin) or Light Green (Verithin). Sharpen outside areas with White (Verithin).

California Poppy

Color Palette

Goldenrod
Pumpkin Orange
Yellow Ochre
Canary Yellow (Lyra)
Sunburst Yellow
Spanish Orange
Yellowed Orange
Dark Orange (Lyra)
Yellow Ochre (Verithin)
White (Verithin)
Olive Green (Verithin)
Limepeel
Dark Umber
Orange (Verithin)
Sienna Brown (Verithin)
Dark Green
Olive Green
Real Green (Spectracolor)
Cool Grey 10%
Light Green (Verithin)

Petals

1 Layer shadow areas with Goldenrod, Pumpkin Orange. Layer Yellow Ochre as shown.

2 Wash with Bestine and a medium brush.

3 Layer a gradation of color, starting from the edge and working to the center of the petal, with Canary Yellow (Lyra), Sunburst Yellow, Spanish Orange, Yellowed Orange, Dark Orange (Lyra). Leave center and highlight area free of color. Drag small amount of color into highlight area with a dry cotton swab.

4 Wash with Bestine and a medium brush.

5 Lightly burnish with Canary Yellow (Lyra), Sunburst Yellow, Spanish Orange, Yellowed Orange, Dark Orange (Lyra), except areas above and below highlight. Repeat until paper surface is completely covered. Sharpen edges with Yellow Ochre (Verithin).

Center

6 Layer Olive Green (Verithin), Limepeel. Wash with Bestine and a very small brush.

7 Layer with Dark Umber. Burnish and sharpen edges with Sienna Brown (Verithin).

8 Using a new #11 X-Acto knife blade, *gently* scrape color away. Burnish with White (Verithin), Yellow Ochre (Verithin). Sharpen edges and decrease width with Orange (Verithin) or Sienna Brown (Verithin).

Leaves and Stems

9 Layer dark values with Dark Green. Layer Olive Green, Real Green (Spectracolor), Limepeel.

10 Burnish with Cool Grey 10%, except darkest values.

11 Burnish with Real Green (Spectracolor), Limepeel. Sharpen edges with Light Green (Verithin).

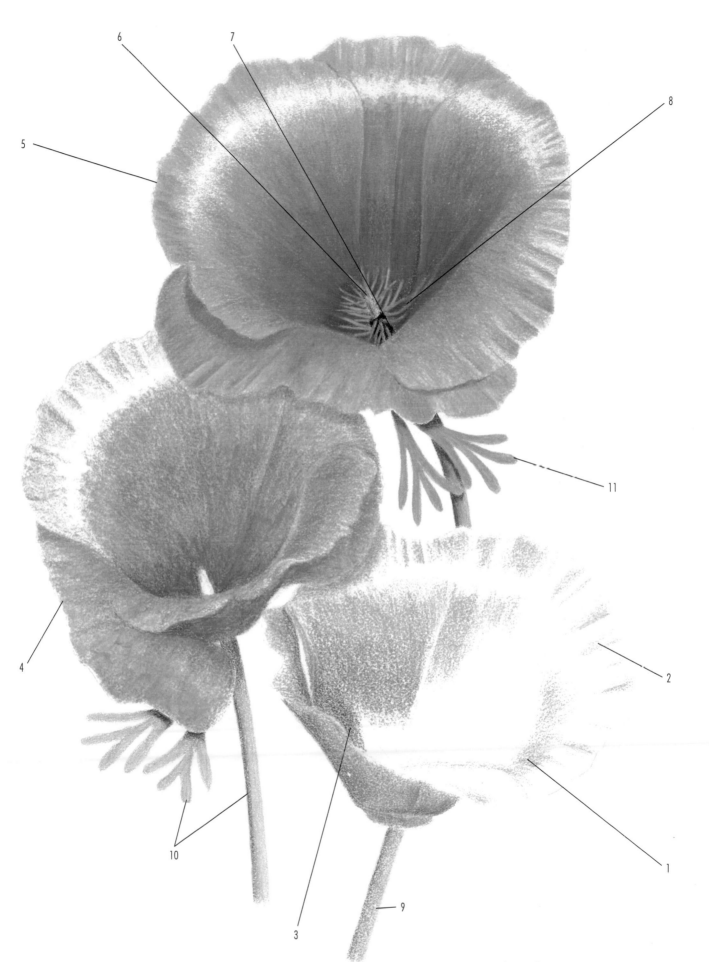

Calla Lily

Color Palette

All colors are Derwent WS unless otherwise noted.

Primrose Yellow
Rose Pink
Pink Madder Lake
Rose Madder Lake
Magenta
Terracotta
Spectrum Orange
Mulberry (Prismacolor)
Dark Purple (Prismacolor)
Imperial Purple
Middle Chrome
Light Violet
Blue Violet Lake
Smalt Blue
White (Prismacolor)
Emerald Green
Delft Blue
Peacock Green (Prismacolor)
True Green (Prismacolor)
Olive Green
Cedar Green
Raw Sienna

Flower

1 Layer Primrose Yellow, Pink Madder Lake, leaving rim free of pigment. Lightly burnish with Rose Pink.

2 Layer Rose Madder Lake, Magenta.

3 Layer stamen with Primrose Yellow, Terracotta, Spectrum Orange, using a diagonal crosshatch stroke.

4 See the flower on the lower right. Layer outside with Mulberry (Prismacolor), Dark Purple (Prismacolor).

5 Lightly burnish stamen with Imperial Purple.

6 Lightly burnish inside with Mulberry (Prismacolor).

7 Burnish edge of rim with Middle Chrome.

8 Layer shadow areas of rim with Light Violet, Blue Violet Lake, Smalt Blue.

9 Burnish rim with White (Prismacolor).

Leaves

10 Layer front with Emerald Green. Burnish with colorless blender, leaving edges free of color. Layer shadows with Delft Blue.

11 Burnish with Emerald Green, Peacock Green (Prismacolor), True Green (Prismacolor).

12 Layer back with Olive Green. Burnish with colorless blender, leaving edges free of color.

13 Layer dark values with Cedar Green. Lightly burnish Olive Green, Raw Sienna.

14 Lightly burnish edges with Middle Chrome, Primrose Yellow.

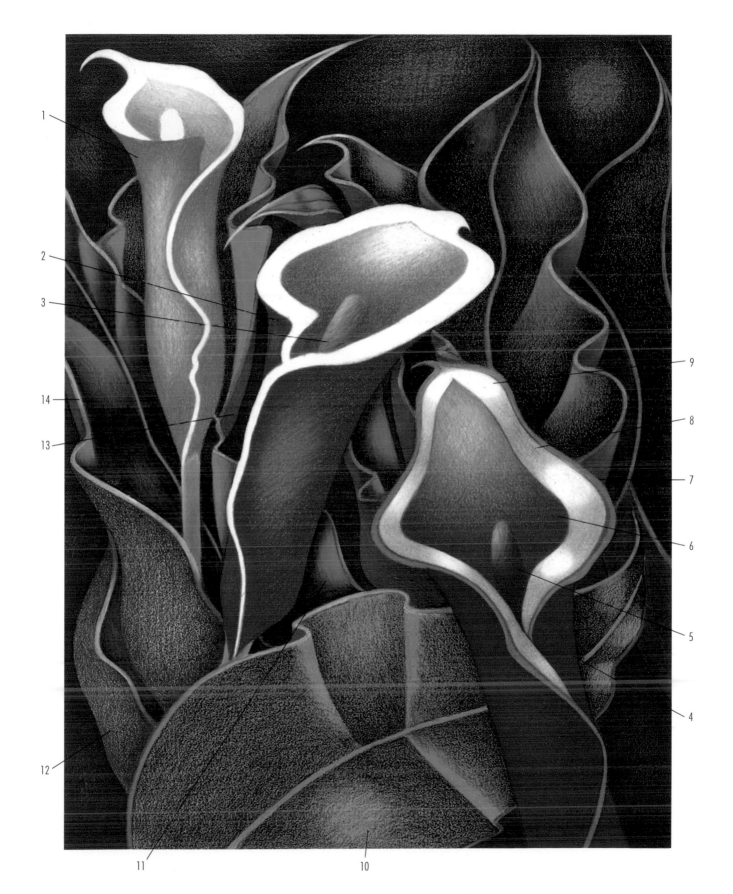

Camellia

Reference photo

Color Palette

All colors are Lyra Rembrandt Polycolor unless otherwise noted.

Light Flesh	Magenta	Hooker's Green
Rose Pink (Derwent WS)	Scarlet Lake	Sky Blue (Derwent Artists)
Dark Flesh	Vermillion	Red Violet
Rose Carmine	Light Orange	Apple Green
Light Carmine	Zinc Yellow	Oriental Blue
Pink Madder Lake	Moss Green	Purple (Prismacolor)
Rose Madder Lake	Peacock Blue	
Wine Red	Sap Green	

1 Layer Light Flesh, Rose Pink (Derwent WS).

2 Layer Dark Flesh, adding more layers in shadow areas. Layer Rose Carmine.

3 Layer flower with Light Carmine, Pink Madder Lake, Rose Madder Lake, Wine Red, Magenta, Scarlet Lake, Vermillion, Light Orange.

4 Layer Zinc Yellow, Moss Green.

5 Layer Peacock Blue, Sap Green.

6 Layer Hooker's Green, Sky Blue (Derwent Artists), Red Violet, Apple Green, Oriental Blue, Purple (Prismacolor).

Carnation

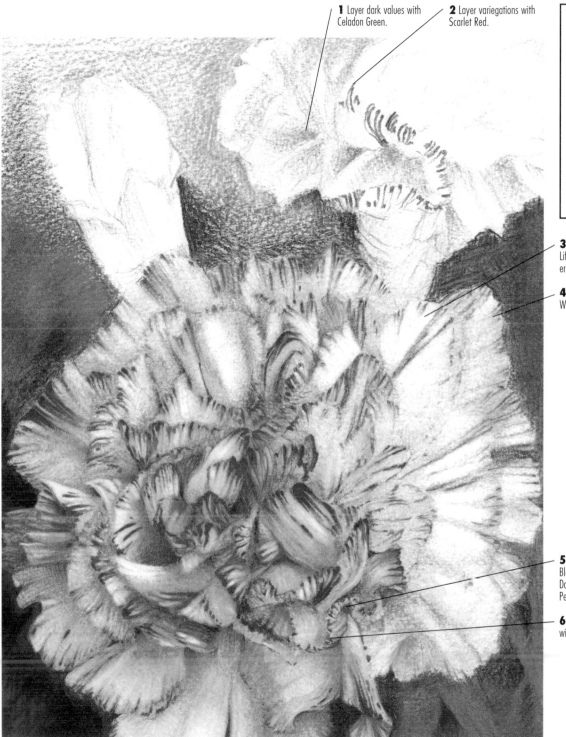

1 Layer dark values with Celadon Green.

2 Layer variegations with Scarlet Red.

Color Palette
Bockingford
tinted drawing
paper

Celadon Green
Poppy Red
Periwinkle
White
Black Grape
Indigo Blue
Dark Green

3 Burnish with cheesecloth. Lift highlights with kneaded eraser.

4 Layer highlights with White.

5 Layer shadows with Black Grape, Indigo Blue, Dark Green, Celadon Green, Periwinkle.

6 Sharpen variegations with Poppy Red.

Chrysanthemum

Color Palette

Mulberry
Magenta
Process Red
Yellow Ochre
Sunburst Yellow
Canary Yellow (Lyra)
Dark Umber
Black
Dark Brown (Verithin)
Black (Verithin)
Cool Grey 10%
Cool Grey 20%
Goldenrod
Tuscan Red
Crimson Lake (Spectracolor)
Poppy Red
White
Rose (Verithin)
Juniper Green (Lyra)
Olive Green
Apple Green
Cream
Olive Green (Verithin)

Center

1 Lightly layer Mulberry, Magenta, Process Red. Wash with Bestine and a cotton swab, dragging color into lighter surrounding area. Then layer Yellow Ochre, Sunburst Yellow, Canary Yellow (Lyra). Wash with Bestine and a cotton swab.

2 Lightly layer with Dark Umber and Black using small circular strokes.

3 Burnish with Dark Umber and Black. Sharpen edges with Black (Verithin) and Dark Brown (Verithin).

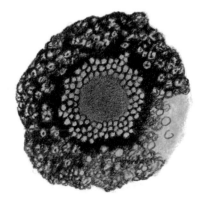

4 Burnish, using small circular strokes, with Dark Umber and Black. Sharpen edges with Black (Verithin) and Dark Brown (Verithin).

Petals

5 Layer Cool Grey 20%, 10%. Wash with Bestine and a cotton swab.

6 Burnish yellow area with Goldenrod, Canary Yellow (Lyra). Wash with Bestine and a small brush.

7 Layer red area with Tuscan Red, Crimson Lake (Spectracolor), Poppy Red.

8 Layer magenta area with Mulberry, Magenta, Process Red. Drag the color into white area with dry cotton swab.

9 Burnish red and magenta areas with White.

10 Burnish red area with Poppy Red and magenta area with Process Red. Repeat step 9 and this step as necessary. Then burnish red and yellow border with Canary Yellow (Lyra), and lightly layer edges with Rose (Verithin).

Chrysanthemum

Leaf and Stem

11 Layer Juniper Green (Lyra), Olive Green, Apple Green.

12 Burnish with Cream. Then burnish with Olive Green, Apple Green. Sharpen edges with Olive Green (Verithin).

Another Chrysanthemum

Color Palette

Canary Yellow (Lyra)
Chartreuse
Olive Green (Verithin)
Light Green (Verithin)
Cool Grey 50%
Cool Grey 30%
Cool Grey 10%
Magenta
Process Red
Hot Pink
White
Pink (Verithin)
Magenta (Verithin)
Rose (Verithin)
White (Verithin)
Juniper Green (Lyra)
Olive Green
Apple Green
Cream

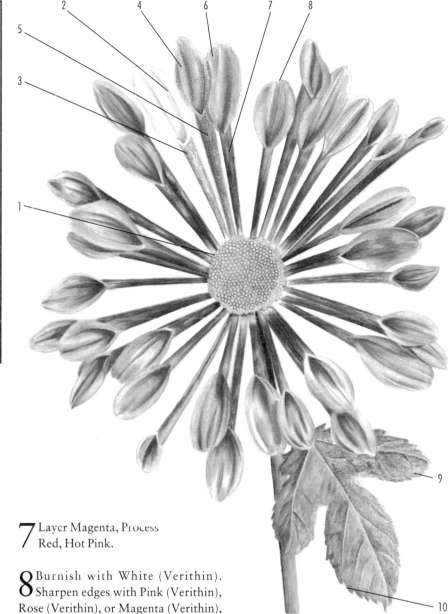

Center

1 Layer Canary Yellow (Lyra). Wash with Bestine and a cotton swab. Then layer Chartreuse on top, leaving yellow edge. Wash with Bestine and a cotton swab. Draw circles in chartreuse area with Olive Green (Verithin) and Light Green (Verithin) on yellow edge.

Petals

2 Layer shadows with Cool Grey 50%, 30% or 10% (depending on value). Wash with Bestine and a small brush.

3 Layer Magenta, Process Red, Hot Pink.

4 Smudge with dry cotton swab, leaving light areas free of color.

5 Wash with Bestine and a small brush.

6 Lightly burnish with White.

7 Layer Magenta, Process Red, Hot Pink.

8 Burnish with White (Verithin). Sharpen edges with Pink (Verithin), Rose (Verithin), or Magenta (Verithin), depending on edge color.

Leaf and Stem

9 Layer Juniper Green (Lyra), Olive Green, Apple Green. Wash with Bestine and a small brush.

10 Lightly burnish with Cool Grey 10%, Cream. Dab with Bestine and a small brush. Sharpen edges with Light Green (Verithin) or Olive Green (Verithin) depending on edge color.

One More Chrysanthemum

Petals

1 Layer Sienna Brown, Hazel (Pablo),
Pumpkin Orange, Pale Vermilion.

2 Layer Dark Orange (Lyra),
Light Orange (Lyra).

3 Layer Yellowed Orange. Leave
highlights free of color.

4 Smudge lightly with dry
cotton swab.

5 Lightly burnish
with White.

Color Palette

Sienna Brown	Light Orange (Lyra)	Cool Grey 10%
Hazel (Pablo)	Yellowed Orange	Dark Green
Pumpkin Orange	White	Olive Green
Pale Vermilion	Orange (Verithin)	Limepeel
Dark Orange (Lyra)	Cool Grey 90%	Olive Green (Verithin)

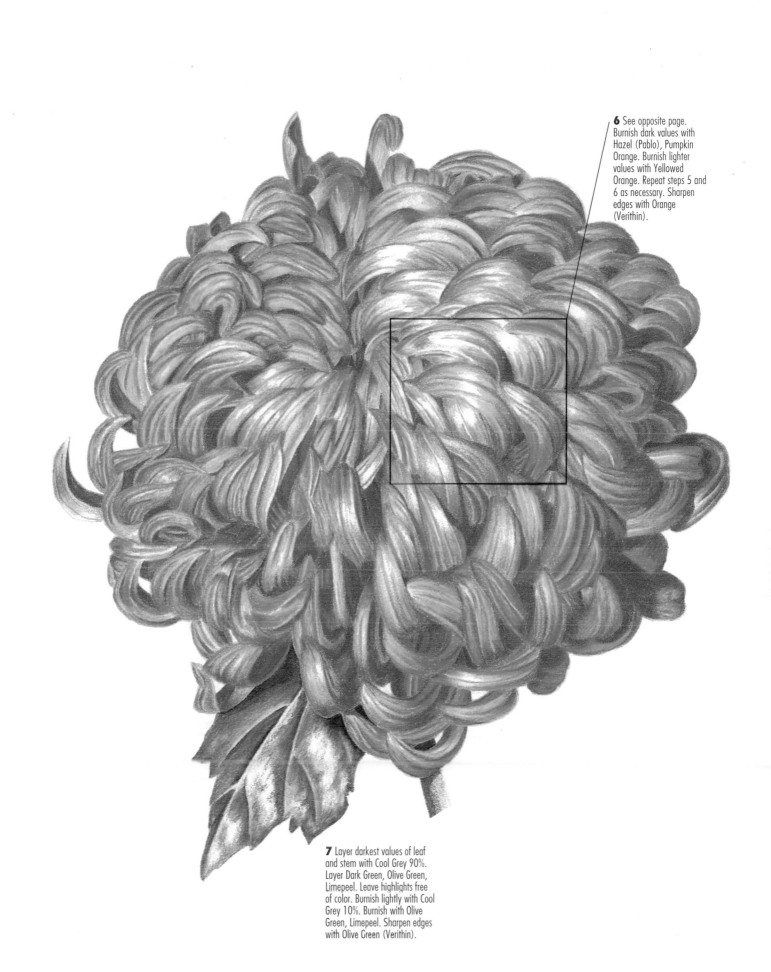

6 See opposite page. Burnish dark values with Hazel (Pablo), Pumpkin Orange. Burnish lighter values with Yellowed Orange. Repeat steps 5 and 6 as necessary. Sharpen edges with Orange (Verithin).

7 Layer darkest values of leaf and stem with Cool Grey 90%. Layer Dark Green, Olive Green, Limepeel. Leave highlights free of color. Burnish lightly with Cool Grey 10%. Burnish with Olive Green, Limepeel. Sharpen edges with Olive Green (Verithin).

Cineraria

Reference photo

Center

1 Layer Sunburst Yellow. Burnish with Canary Yellow (Lyra).

2 Layer Tuscan Red, Magenta, Process Red.

3 Dab with Bestine and a cotton swab.

4 Burnish with White.

5 Burnish with Tuscan Red, Process Red. Repeat steps 3 and 4. Sharpen edges with Magenta (Verithin) or Tuscan Red (Verithin).

Petals

6 Layer white area in center with Cool Grey 30%, 10%, leaving highlights free of color.

7 Layer dark values with Lavender. Layer Process Red, Carmine Red, Hot Pink.

8 Wash with Bestine and a cotton swab.

9 Burnish with White, including gray shadows from step 6. Don't burnish darkest values or edge adjacent to white area.

10 Lightly burnish with Process Red, Carmine Red. Burnish with Hot Pink. Sharpen edges with Magenta (Verithin).

Leaves and Stem

11 Layer Grass Green, Olive Green, Emerald Green (Lyra), Spring Green.

12 Burnish with Cool Grey 20%. Lightly burnish Grass Green, Olive Green, Emerald Green (Lyra). Burnish with Spring Green, Olive Green. Lightly erase stem with kneaded eraser. Sharpen edges with Grass Green (Verithin), Light Green (Verithin).

Color Palette

Sunburst Yellow
Canary Yellow (Lyra)
Tuscan Red
Magenta
Process Red
White
Magenta (Verithin)
Tuscan Red (Verithin)
Cool Grey 10%
Cool Grey 20%
Cool Grey 30%
Lavender
Carmine Red
Hot Pink
Grass Green
Olive Green
Emerald Green (Lyra)
Spring Green
Grass Green (Verithin)
Light Green (Verithin)

Crocus

Reference photo

Note: There are two different types of petal, one with clear variegations (petal A), the other with color between variegations (petal B). The color palettes are the same, but the petals are rendered somewhat differently.

Petals

1 Layer center with Cool Grey 50%. Wash with Bestine and a cotton swab. Layer inside of petals and edge of petal where it folds over with Cool Grey 20%. Be careful to leave white edge at the end of each petal free of color. Wash with Bestine and a cotton swab.

2 Layer variegations with Parma Violet, Lavender and Lilac on inside of petal only. Petal A: Smudge with dry cotton swab into lighter areas next to variegations. Petal B: Lightly layer Parma Violet and Lavender, smudge with a dry cotton swab, then wash with a small amount of Bestine and a cotton swab.

3 Burnish lighter, smudged areas of petal A with Cool Grey 10%, and randomly burnish variegations with White, using light pressure. Randomly burnish petal B with Parma Violet, Lavender and Cool Grey 20%.

4 Draw thinner variegations with Lavender (Verithin), and burnish folded-over area of petal with Lavender, leaving white edge free of color. Draw veins in center of large variegations with Black Grape and Violet (Verithin).

Pistil and Stamen

5 Layer entire area with Sunburst Yellow. Wash with Bestine and a cotton swab. Burnish with Goldenrod and Spanish Orange.

Leaves

6 Layer French Grey 70%, 10%, 20%.

7 Burnish all but the center area with Sea Green (Lyra), Olive Green. Drag green into light center area by smudging with dry cotton swab. Sharpen edges with Olive Green (Verithin).

Pollen

8 With sharpened imbibed eraser strip in electric eraser, erase small areas, then burnish with Spanish Orange and Sunburst Yellow.

Color Palette

Cool Grey 50%
Cool Grey 20%
Cool Grey 10%
Parma Violet
Lavender
Lilac
White
Lavender (Verithin)
Black Grape
Violet (Verithin)
Sunburst Yellow
Goldenrod
Spanish Orange
French Grey 10%
French Grey 20%
French Grey 70%
Sea Green (Lyra)
Olive Green
Olive Green (Verithin)

Columbine

Center

1 Burnish Sunburst Yellow. Burnish edges with Goldenrod.

2 Layer Cool Grey 20%. Wash with Bestine and a medium brush. Layer Sunburst Yellow. Wash with Bestine and a medium brush. Lightly draw lines with Light Grey (Verithin), Goldenrod, Lavender (Verithin).

Yellow Petals

3 Layer dark values with Goldenrod. Wash with Bestine and a medium brush.

4 Layer Sunburst Yellow, Canary Yellow (Lyra). Lightly burnish with White, except darkest values. Burnish with Sunburst Yellow, Canary Yellow (Lyra). Repeat burnishing with White, Sunburst Yellow and Canary Yellow (Lyra) as necessary. Sharpen edges with Yellow Ochre (Verithin).

Lavender Petals

5 Layer dark values with Violet. Layer Parma Violet, Lilac, Lavender.

6 Burnish with White, except darkest values. Burnish dark values with Parma Violet. Burnish with Lilac, Lavender. Repeat as necessary. Sharpen edges with Lavender (Verithin) or White (Verithin).

Lavender and Yellow Petals

7 Layer Goldenrod, Sunburst Yellow, Canary Yellow (Lyra). Wash with Bestine and a cotton swab. Lightly layer Lilac, Lavender into yellow area. Wash with Bestine and a small brush. Layer dark values with Violet, Parma Violet. Then lightly burnish with White, except darkest values. Now lightly burnish with Lilac, Sunburst Yellow. Repeat, starting with Violet and Parma Violet, until smooth gradation is achieved.

Stem

8 Layer Tuscan Red, Olive Green, Limepeel. Burnish with White. Lightly burnish with Tuscan Red, Olive Green, Limepeel. Repeat burnishing as necessary. Sharpen edges with Tuscan Red (Verithin) and Olive Green (Verithin).

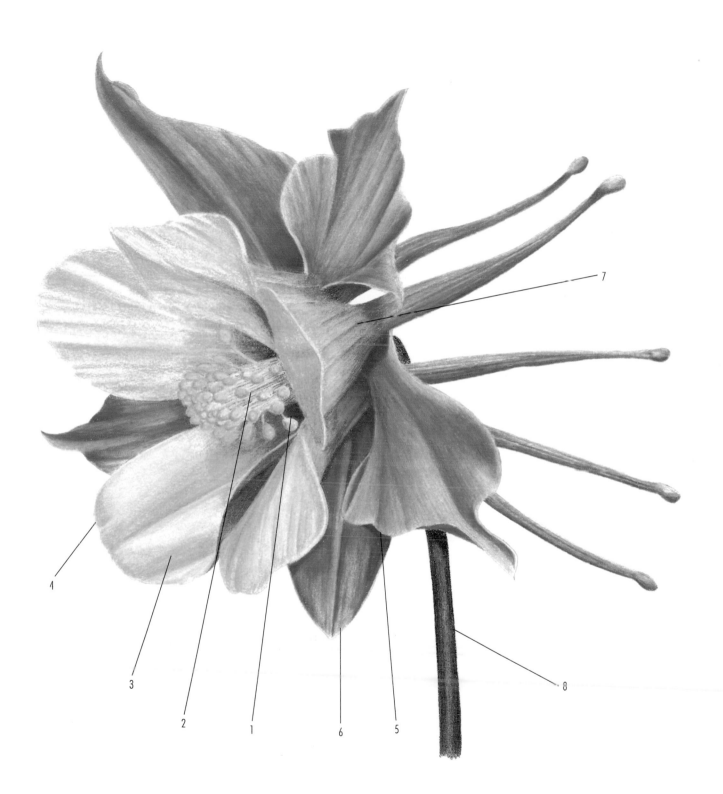

1

3

2

1

6

5

8

7

Daffodil

Yellow Petals

1 Layer darkest values with Chocolate. Layer Naples Yellow, Primrose Yellow, Deep Cadmium, Gold, Jade Green. Define edges with Gold (Verithin), Dark Brown (Verithin), Indigo Blue (Verithin).

2 Burnish with Cream (Prismacolor). Repeat steps 1 and 2 as necessary. Sharpen edges with Chocolate.

White Petals

3 Layer darkest values/shadows with Slate Grey (Spectracolor), Indigo Blue (Verithin). Lightly layer Jade Green, Juniper Green, Primrose Yellow, leaving lightest values free of color.

4 Burnish with White (Prismacolor).

5 Lightly layer shadows with Juniper Green, Jade Green. Lightly layer Primrose Yellow, Deep Cadmium. Repeat steps 4 and 5 as necessary. Sharpen edges with Juniper Green or Indigo Blue (Verithin).

Leaves and Stem

6 Layer darker values with Indigo Blue (Prismacolor), Dark Green (Prismacolor). Layer middle values with Juniper Green. Layer light values/stems with Green Grey.

7 Impress veins with 7H graphite pencil and drafting or tracing paper. Lightly burnish with Cream (Prismacolor). Lightly burnish shadows with Indigo Blue (Prismacolor). Lightly burnish Juniper Green, Dark Green. Repeat burnishing in same order as necessary. Sharpen edges with Indigo Blue (Verithin).

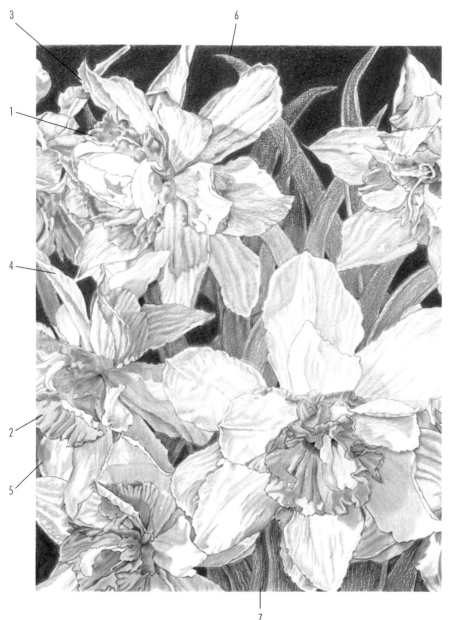

Color Palette
All colors are Derwent Artists unless otherwise noted.

Naples Yellow	Juniper Green
Primrose Yellow	Slate Grey (Spectracolor)
Deep Cadmium	White (Prismacolor)
Gold	Cream (Prismacolor)
Jade Green	Chocolate
Gold (Verithin)	Indigo Blue (Prismacolor)
Dark Brown (Verithin)	Dark Green (Prismacolor)
Indigo Blue (Verithin)	Green Grey

Dahlia

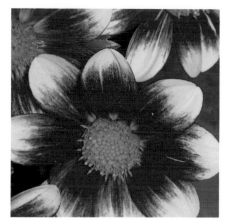

Reference photo

Center

1 Define dark values by burnishing with Golden Brown (Verithin).

2 Layer Spanish Orange, Sunburst Yellow. Dab with Bestine and a small brush.

3 Redefine dark values with Hazel (Pablo). With sharpened imbibed eraser strip in an electric eraser, erase highlight areas. Dab with Bestine and a small brush.

Petals

4 Layer Sunburst Yellow, Canary Yellow (Lyra).

5 Wash with Bestine and a cotton swab.

6 Layer Crimson Red, Pale Geranium Lake (Lyra), Poppy Red.

7 Lightly burnish with Canary Yellow (Lyra).

8 Burnish with Scarlet Lake. Lightly burnish with Canary Yellow (Spectracolor) where red meets the yellow area. Sharpen red edges with Carmine Red (Verithin) and yellow edges with Yellow Ochre (Verithin).

Leaf

9 Layer dark values with Cool Grey 90%. Layer Olive Green, Apple Green. Burnish with Cool Grey 10%.

10 Layer Olive Green, Apple Green. Burnish with Cream, Olive Green (dark values), Apple Green (light values). Sharpen edges with Olive Green (Verithin).

Stem

11 Layer Cool Grey 90%, Olive Green, Tuscan Red, Light Umber. Burnish with Cool Grey 10%. Lightly burnish Cool Grey 90%, Olive Green, Tuscan Red, Light Umber. Sharpen edges with Olive Green (Verithin) or Tuscan Red (Verithin).

Color Palette

Golden Brown (Verithin)
Spanish Orange
Sunburst Yellow
Hazel (Pablo)
Canary Yellow (Lyra)
Crimson Red
Pale Geranium Lake (Lyra)
Poppy Red
Scarlet Lake
Canary Yellow (Spectracolor)
Carmine Red (Verithin)
Yellow Ochre (Verithin)
Cool Grey 90%
Cool Grey 10%
Olive Green
Apple Green
Cream
Olive Green (Verithin)
Tuscan Red
Light Umber
Tuscan Red (Verithin)

Another Dahlia

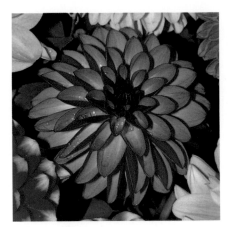

Reference photo

Color Palette

Sunburst Yellow
Olive Green
Cool Grey 70%
Lavender
Mulberry
Magenta
White
Magenta (Verithin)
White (Verithin)
Juniper Green (Lyra)
Apple Green
Cream
Light Green (Verithin)
Olive Green (Verithin)

Petals

1 See opposite page. Layer Sunburst Yellow. Wash with Bestine and a small brush. Layer Olive Green in areas shown only. Wash with Bestine and a very small brush.

2 Layer shadows with Cool Grey 70%. Wash with Bestine and a small brush. Layer Lavender on top. Wash with Bestine and a small brush.

3 Lightly layer Mulberry, Lavender, Magenta, leaving highlights free of color.

4 Smudge with a dry cotton swab.

5 Wash with Bestine and a small brush.

6 Lightly burnish with White.

7 Repeat steps 3 and 6 as required.

8 Layer Mulberry, Magenta.

9 Burnish with White.

10 Burnish with Mulberry, Magenta. Sharpen dark edges with Magenta (Verithin) and light edges with White (Verithin).

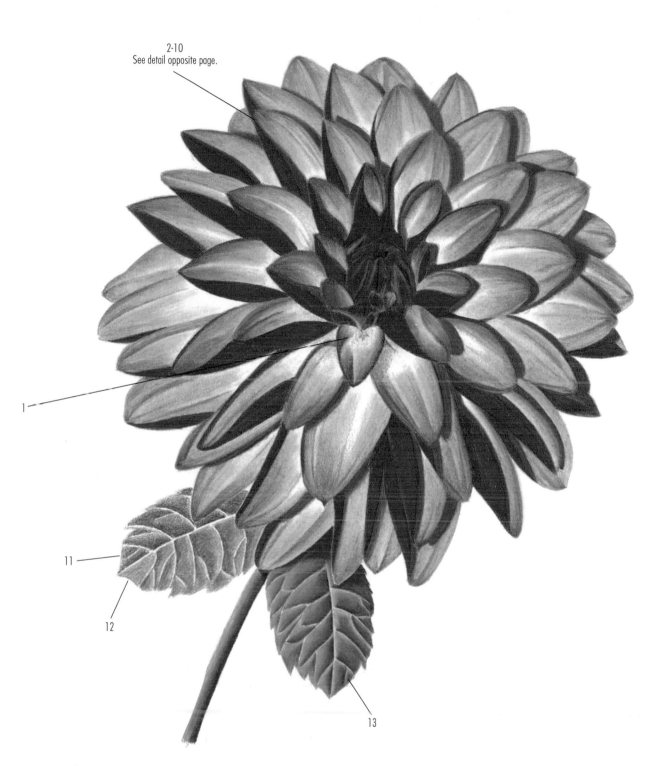

2-10
See detail opposite page.

1

11

12

13

Leaves and Stem

11 Layer shadows with Cool Grey 70%. Layer Juniper Green (Lyra), Olive Green, Apple Green.

12 Lightly burnish with Cream.

13 Burnish with Olive Green, Apple Green. Repeat steps 12 and 13 as necessary. Sharpen edges with Light Green (Verithin) or Olive Green (Verithin).

Easter Cactus

Reference photo—
flowers

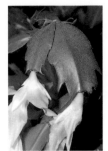

Reference photo—
leaves

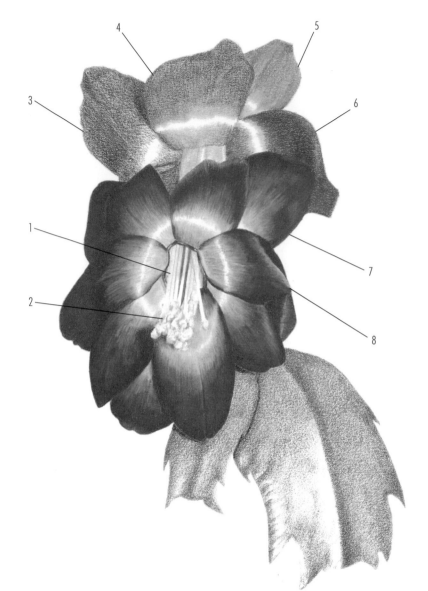

Color Palette

French Grey 10%	Rose (Verithin)
French Grey 30%	Carmine Red
Light Grey (Verithin)	(Verithin)
Goldenrod	Dark Green
Yellow Ochre	Grass Green
Jasmine	Olive Black (Pablo)
Henna	Olive Green
Magenta	Real Green
Process Red	(Spectracolor)
Carmine Red	Green Ochre (Pablo)
(Spectracolor)	Olive Green
White	(Verithin)
Magenta (Verithin)	

Pistils and Stamen

1 Layer French Grey 30%, 10%. Wash with Bestine and a small brush. Lightly burnish with French Grey 10%. Define edges with Light Grey (Verithin).

2 Layer Goldenrod, Yellow Ochre, Jasmine. Wash with Bestine and a small brush. Burnish with Jasmine, leaving some areas free of color. Burnish light values with White.

Petals

3 Layer shadows with Henna. Layer Magenta, Process Red, Carmine Red (Spectracolor), leaving light values and highlights free of color.

4 Smudge pigment into light areas with cotton swab, leaving highlight free of color.

5 Lightly burnish with White.

6 Lightly burnish with Magenta, Process Red, Carmine Red (Spectracolor).

7 Burnish with White.

8 Burnish with Carmine Red (Spectracolor). Sharpen edges with Magenta (Verithin), Rose (Verithin), or Carmine Red (Verithin).

Leaves

9 Layer dark values with Dark Green, Grass Green. Layer Olive Black (Pablo), Olive Green, Real Green (Spectracolor), Green Ochre (Pablo), leaving highlights free of color. Sharpen edges with Olive Green (Verithin).

Foxglove

Color Palette

Tuscan Red
Tuscan Red (Verithin)
Cool Grey 10%
Cool Grey 20%
Cool Grey 90%
Henna
Magenta
Process Red
Rosy Beige
Clay Rose
Pink Rose
Hot Pink
Pink
Deco Pink
White
Scarlet Lake
Carmine Red (Verithin)
Rose (Verithin)
Juniper Green (Lyra)
Olive Green
Limepeel
Olive Green (Verithin)

Flowers

1 Burnish spots with Tuscan Red, leaving surrounding area free of color. Sharpen edges with Tuscan Red (Verithin).

2 Burnish spots in shadow with Cool Grey 90% and Tuscan Red.

3 Layer shadows and darkest values with Tuscan Red, Henna, Magenta.

5 Layer Hot Pink, Pink, Pink Rose, Deco Pink.

6 Wash with Bestine and a medium brush.

7 Lightly burnish with White, except shadows.

4 Layer midtone values with Process Red, Rosy Beige, Clay Rose, Pink Rose.

8 Burnish shadow and darkest values with Tuscan Red, Henna.

9 Burnish around spots in shadow with White.

10 Burnish darkest values on outer part of flower with Scarlet Lake.

Foxglove

Leaves

11 To finish flowers burnish with Process Red, Hot Pink, Deco Pink, White. Repeat steps 7–9 as necessary. Sharpen edges with Tuscan Red (Verithin), Carmine Red (Verithin) or Rose (Verithin). Layer white area with Cool Grey 20%. Burnish with White, dragging color into the area and leaving some paper free of color.

12 Layer Cool Grey 90% (shadows only), Juniper Green (Lyra), Olive Green, Limepeel. Lightly burnish with Cool Grey 10% (except shadows). Layer Henna to areas as shown. Burnish with Olive Green, Limepeel. Sharpen edges with Olive Green (Verithin).

Foxglove

Another View by Judy McDonald

7 Layer Grass Green on leaves and stems, leaving lightest values free of color.

8 Layer darker values with Dark Green, Olive Green. Layer middle values with True Green, Light Green, Spring Green.

9 Burnish with White, Cream.

1 Layer Mulberry, Jasmine, leaving lightest values free of color.

2 Layer spots with Purple.

3 Layer Hot Pink, Process Red, leaving highlights free of color. Burnish with White, Cream.

4 Lightly burnish top of flower with Deco Yellow. Lightly burnish with Hot Pink, Process Red, Magenta.

5 Lightly burnish edges with Blush Pink, Dahlia Purple.

6 Burnish spots with Dahlia Purple.

Color Palette

Mulberry	Cream	Dark Green
Jasmine	Deco Yellow	Olive Green
Purple	Magenta	True Green
Hot Pink	Blush Pink	Light Green
Process Red	Dahlia Purple	Spring Green
White	Grass Green	

Fuchsia

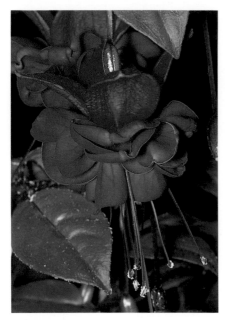

Reference photo

Color Palette

Cool Grey 70%
Crimson Red
Scarlet Lake
Magenta
Carmine Red
White
Carmine Red (Verithin)
Black Grape
Imperial Violet
Violet (Lyra)
Lilac
Lavender
Mulberry
Lavender (Verithin)
Light Grey (Verithin)
Rose (Verithin)
French Grey 20%
French Grey 70%
Terra Cotta
Warm Grey 90%
Olive Green (Lyra)
Olive Green
Apple Green (Lyra)
Olive Green (Verithin)

Red Petals

1 Layer shadows with Cool Grey 70% and Crimson Red. Layer Scarlet Lake, Magenta, Carmine Red.

2 Burnish with White, except shadow areas.

3 Burnish with Scarlet Lake (dark values), Carmine Red, White (light values). Repeat as required. Sharpen edges with Carmine Red (Verithin).

Lavender Petals

4 Layer shadows with Cool Grey 70% and Black Grape. Layer dark values with Imperial Violet. Layer Violet (Lyra), Lilac, Lavender, Carmine Red.

5 Burnish with White, except shadow areas.

6 Lightly layer Mulberry on random petals. Burnish with Violet (Lyra), Lilac, Lavender. Burnish light values with White. Repeat as required. Sharpen edges with Lavender (Verithin).

Pistil and Stamen

7 Using sharp Verithins, layer Light Grey (shadows), Carmine Red, Rose. Burnish with White. Burnish with Rose (Verithin). Burnish the left side of pistil with White.

8 Layer ends of pistils with French Grey 20%, 70%. Randomly burnish with White.

Stem and Leaves

9 Layer stem with Terra Cotta. Burnish with French Grey 20%. Burnish with Terra Cotta.

10 Layer dark values with Warm Grey 90%. Layer pod with Olive Green (Lyra), Olive Green. Burnish with Apple Green (Lyra), Olive Green. Leave highlights free of color.

11 Draw leaf veins with Terra Cotta. Layer dark values with Warm Grey 90%. Layer Olive Green (Lyra), Olive Green.

12 Burnish with White, Apple Green (Lyra), Olive Green. Repeat as required. Sharpen edges with Olive Green (Verithin).

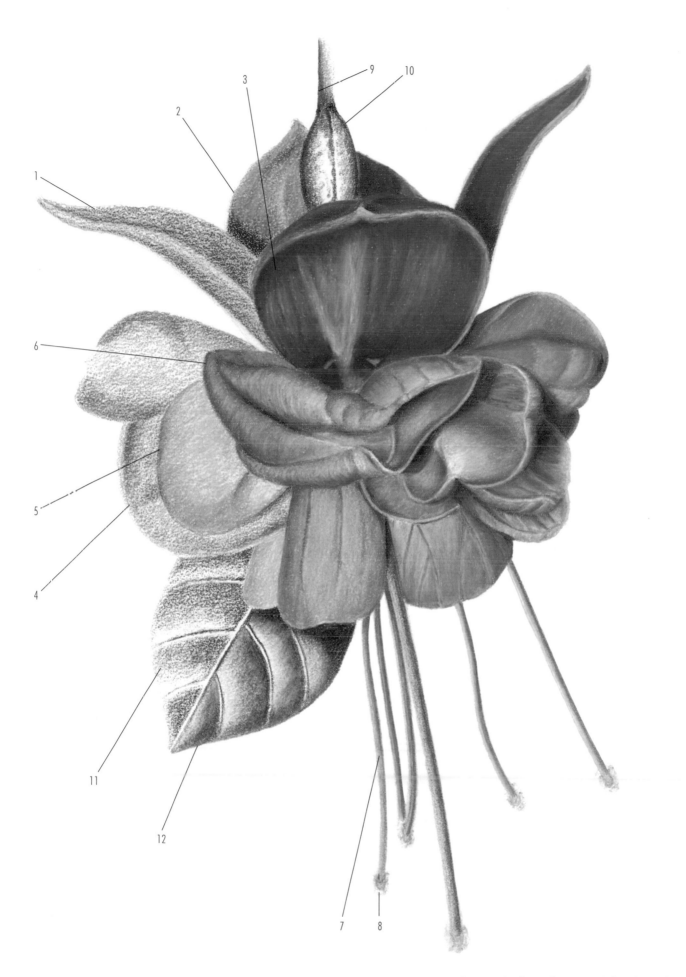

Geranium

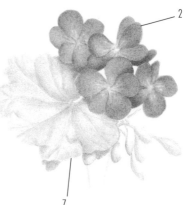

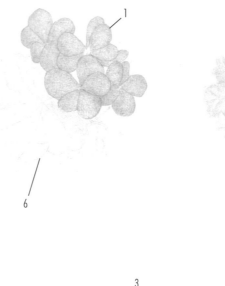

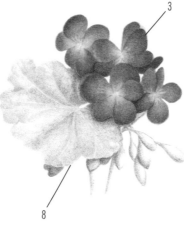

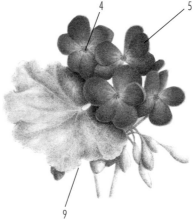

Color Palette

All colors are Lyra Rembrandt Polycolor unless otherwise noted.

Pink Madder Lake
Rose Madder Lake
Red Violet
Magenta
Light Carmine
Dark Carmine
Vermillion
Apple Green
Wine Red
Purple (Prismacolor)
Peacock Blue
Sap Green
Hooker's Green
Oriental Blue

Flower

1 Layer Pink Madder Lake.

2 Layer Rose Madder Lake. Layer shadows with Red Violet, Magenta.

3 Layer Light Carmine, Dark Carmine.

4 Layer center with tiny strokes of Dark Carmine, Vermillion, Apple Green.

5 Layer shadows with Wine Red, Purple (Prismacolor), Vermillion.

Leaves

6 Layer Apple Green.

7 Layer Peacock Blue.

8 Layer Sap Green.

9 Layer Hooker's Green. Layer shadows with Oriental Blue, Wine Red, Purple (Prismacolor). Lightly layer Dark Carmine on leaf surface.

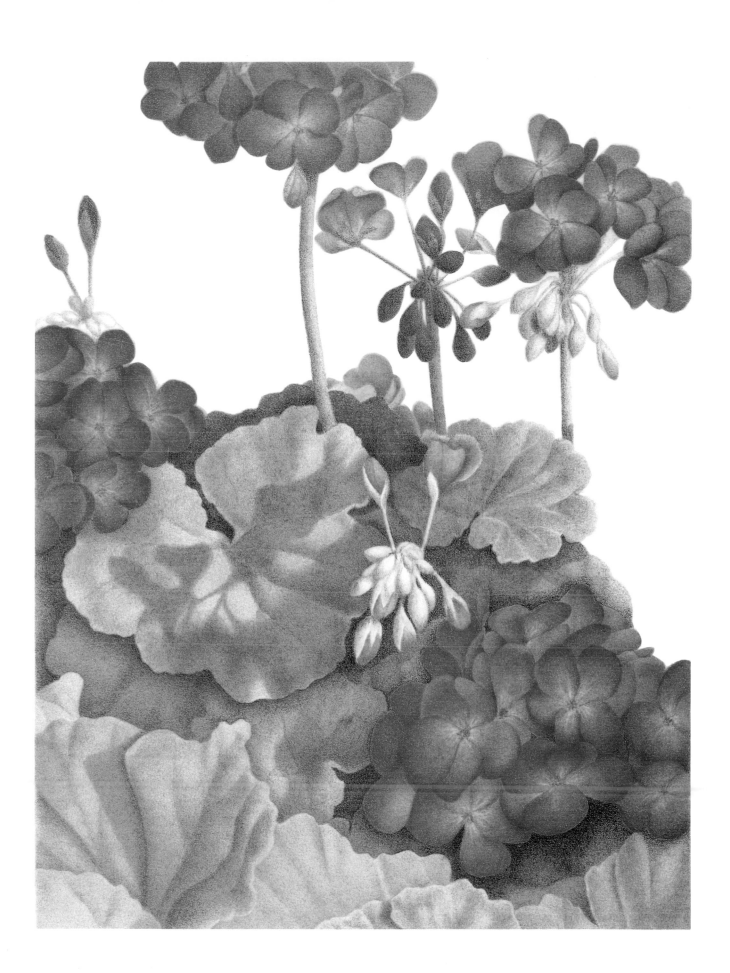

Gerbera Daisy

Center

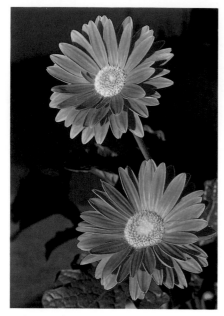

Reference photo

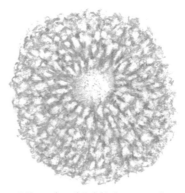

Color Palette

Cream (Lyra)
Yellow Ochre
Goldenrod
French Grey 10%
French Grey 30%
French Grey 50%
French Grey 90%
Spanish Orange
Sunburst Yellow
Canary Yellow (Lyra)
Pumpkin Orange
Yellowed Orange
White (Verithin)
Yellow Ochre (Verithin)
Juniper Green (Lyra)
Olive Green

1 Layer Cream (Lyra). Wash with Bestine and a cotton swab.

2 Layer Yellow Ochre, except in center. Wash with Bestine and a cotton swab.

3 Burnish with Goldenrod. Dab with Bestine and a cotton swab.

4 Develop highlight areas by erasing randomly with a sharpened imbibed eraser strip in an electric eraser. Layer center with Yellow Ochre. Lightly burnish shadows with French Grey 30%.

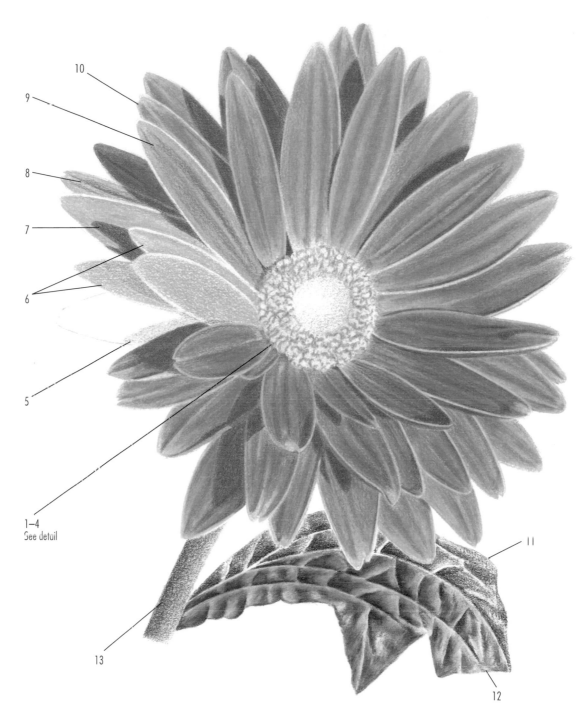

10

9

8

7

6

5

1–4
See detail

11

12

13

Petals

5 Layer shadows with French Grey 50%. Wash with Bestine and a cotton swab.

6 Layer Spanish Orange, Sunburst Yellow, Canary Yellow (Lyra), leaving edges free of color. Wash with Bestine and a cotton swab.

7 Burnish shadows with Pumpkin Orange.

8 Layer Pumpkin Orange, Yellowed Orange. Wash with Bestine and a medium-small brush.

9 Burnish with Sunburst Yellow.

10 Lightly layer edges with Sunburst Yellow. Burnish with White (Verithin). Sharpen edges with Yellow Ochre (Verithin).

Leaf

11 Layer French Grey 90%, Juniper Green (Lyra), Olive Green.

12 Burnish with French Grey 10%. Then burnish with Juniper Green (Lyra), French Grey 30%.

Stem

13 Layer French Grey 90%, Juniper Green (Lyra), Olive Green.

Gladiolus

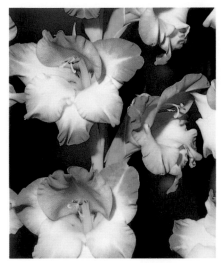

Reference photo

Color Palette

French Grey 10%
French Grey 20%
French Grey 30%
French Grey 50%
Cream (Lyra)
Cream
Pale Yellow (Pablo)
Goldenrod
Yellow Ochre
Light Ochre (Lyra)
Cinnamon (Lyra)
Dark Flesh (Lyra)
Salmon Pink
Deco Orange
White
Apple Green
Henna
Tuscan Red (Verithin)
Cool Grey 10%
Cool Grey 30%
Cool Grey 70%
Olive Green
Olive Green (Verithin)

Petals

See the bottom flower on the opposite page for steps 1–7.

1 Layer shadows, dark values and light yellow areas with French Grey 30%, 20%, 10%. Wash with Bestine and a medium-small brush.

2 Layer Cream (Lyra), Cream, Pale Yellow (Pablo). Wash with Bestine and a medium-small brush.

3 Layer Goldenrod, Yellow Ochre, Light Ochre (Lyra). Wash with Bestine and a medium-small brush.

4 Layer shadows, dark values and salmon areas with French Grey 50%, Cinnamon (Lyra).

5 Layer Dark Flesh (Lyra), Salmon Pink, Deco Orange. Wash with Bestine and a medium-small brush.

6 Burnish light yellow areas with Cream and White (light values only). Overlap into salmon area.

7 Burnish salmon areas with Dark Flesh (Lyra), Salmon Pink, Deco Orange.

Pistils and Center

See the top flower on the opposite page for steps 8–10.

8 Layer French Grey 30%, 10%. Wash with Bestine and a small brush. Layer Cream. Wash with Bestine and a small brush.

9 Lightly layer Apple Green. Wash with Bestine and a small brush.

10 Lightly burnish darker values with French Grey 20% to define pistils. Layer Henna to accent areas of inner petals. Wash with Bestine and a small brush. Burnish with Tuscan Red (Verithin).

Stem and Buds

11 Layer dark values with Cool Grey 70%. Layer Cool Grey 30%, Olive Green, Apple Green.

12 Burnish with Cool Grey 10%. Wash with Bestine and a cotton swab. Burnish dark values with Olive Green. Burnish Apple Green, Cool Grey 10%. Repeat washing and burnishing as necessary. Sharpen edges with Olive Green (Verithin).

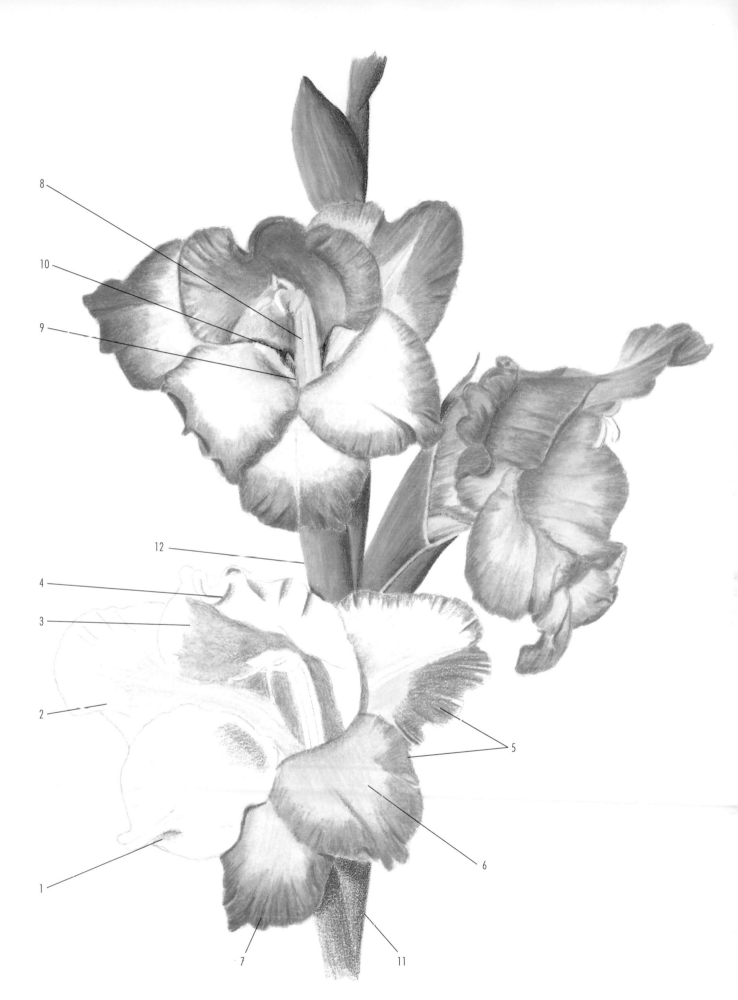

Hibiscus

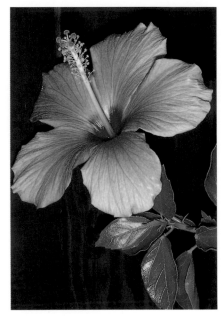

Reference photo

Color Palette

Orange (Verithin)
Jasmine
Deco Orange
Blush
White
French Grey 10%
French Grey 20%
White (Verithin)
Goldenrod
Cream (Lyra)
Cream
Spanish Orange
Pale Vermilion
Warm Grey 70%
Warm Grey 90%
Tuscan Red
Crimson Red
Dark Grey (Verithin)
Juniper Green (Lyra)
Sap Green (Lyra)
Moss Green (Lyra)
Apple Green

Petals

1 Lightly define veins with Orange (Verithin). Layer with Jasmine, leaving highlight area adjacent to veins free of color. Layer with Deco Orange and Blush.

2 Burnish with White.

3 Lightly burnish shadows with French Grey 20%. Wash with Bestine and a cotton swab. Burnish with Blush, Deco Orange, Jasmine. Lightly layer vein highlights with Jasmine. Burnish with White (Verithin).

Pistil and Stamen

4 Layer left edge with French Grey 10%, Goldenrod, Cream (Lyra). Burnish with Cream.

5 Burnish left edge with Spanish Orange, Goldenrod.

6 Layer with Pale Vermilion, Deco Orange. Burnish with Cream. Burnish edge with Pale Vermilion.

7 Burnish with Cream (Lyra), Goldenrod.

Center

8 Layer with Warm Grey 90%, Tuscan Red, Crimson Red.

9 Lightly burnish lighter values with Blush. Burnish with Crimson Red.

Leaves

10 Draw veins with Dark Grey (Verithin). Layer Warm Grey 70%, Juniper Green (Lyra), Sap Green (Lyra), Moss Green (Lyra), leaving highlights free of color.

11 Burnish with Apple Green.

12 Burnish with Sap Green (Lyra), Moss Green (Lyra). Layer vein highlights with Apple Green. Burnish with White (Verithin).

Hollyhock

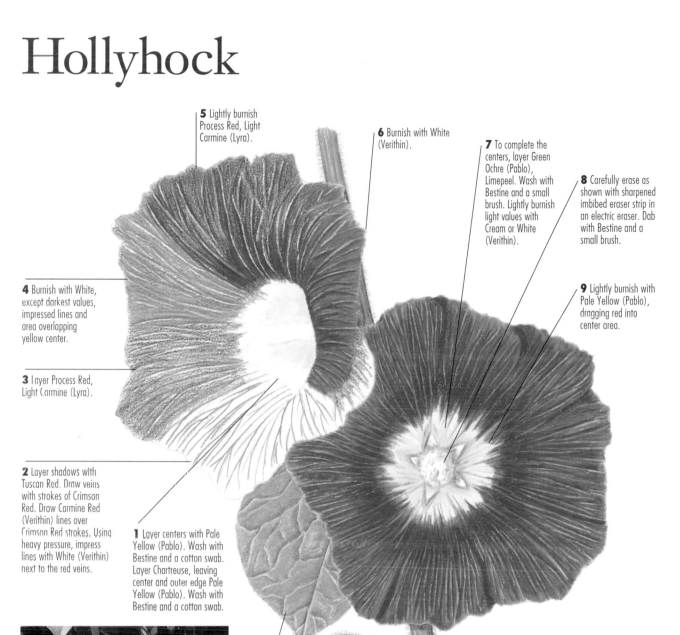

5 Lightly burnish Process Red, Light Carmine (Lyra).

6 Burnish with White (Verithin).

7 To complete the centers, layer Green Ochre (Pablo), Limepeel. Wash with Bestine and a small brush. Lightly burnish light values with Cream or White (Verithin).

8 Carefully erase as shown with sharpened imbibed eraser strip in an electric eraser. Dab with Bestine and a small brush.

4 Burnish with White, except darkest values, impressed lines and area overlapping yellow center.

9 Lightly burnish with Pale Yellow (Pablo), dragging red into center area.

3 Layer Process Red, Light Carmine (Lyra).

2 Layer shadows with Tuscan Red. Draw veins with strokes of Crimson Red. Draw Carmine Red (Verithin) lines over Crimson Red strokes. Using heavy pressure, impress lines with White (Verithin) next to the red veins.

1 Layer centers with Pale Yellow (Pablo). Wash with Bestine and a cotton swab. Layer Chartreuse, leaving center and outer edge Pale Yellow (Pablo). Wash with Bestine and a cotton swab.

Reference photo

10 Draw veins with Juniper Green (Lyra). Using heavy pressure, impress lines with White (Verithin) next to the veins. Then layer Olive Green, Apple Green. Lightly burnish with Cream and Cool Grey 10%. Lightly burnish with Olive Green, Apple Green. Wash with Bestine and a small brush. Using small, light strokes, layer hair with Light Green (Verithin).

Color Palette

Pale Yellow (Pablo)	White (Verithin)	Cream
Chartreuse	Process Red	Juniper Green (Lyra)
Tuscan Red	Light Carmine (Lyra)	Olive Green
Crimson Red	White	Apple Green
Carmine Red (Verithin)	Green Ochre (Pablo)	Cool Grey 10%
	Limepeel	Light Green (Verithin)

Hydrangea

Reference photo—petals

Reference photo—leaves

Color Palette

French Grey 90%
French Grey 70%
French Grey 50%
French Grey 30%
Light Ochre (Lyra)
Jasmine
Deco Yellow
Cream
Violet
Parma Violet
Light Violet (Lyra)
Lilac
Greyed Lavender
Lavender
Pink
Deco Pink
White
Lavender (Verithin)
White (Verithin)
Olive Black (Pablo)
Olive Green
Cedar Green (Lyra)
Green Ochre (Pablo)
Olive Green (Verithin)

Petals

1 Layer shadows with French Grey 70%. Wash with Bestine and a small brush.

2 Layer Light Ochre (Lyra), Jasmine, Deco Yellow, Cream. Wash with Bestine and a small brush. Lightly burnish with French Grey 50%, 30%. Wash with Bestine and a small brush.

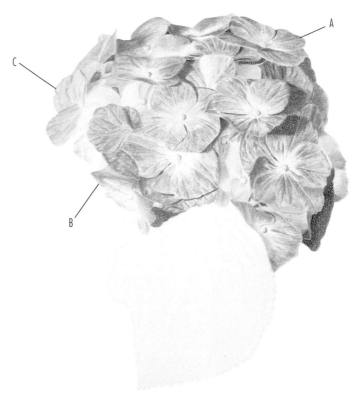

3 A: Layer dark values with French Grey 70% and Violet. Layer with Parma Violet, Light Violet (Lyra), Lilac, Greyed Lavender, Lavender, Pink, Deco Pink. B: Wash with Bestine and a small brush. C: Lightly burnish with White, except darkest values.

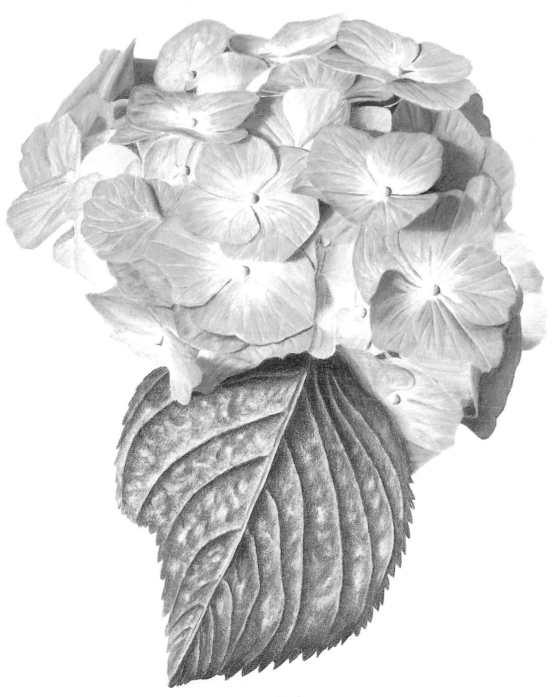

Leaf

4 To finish the petal, lightly burnish with Light Violet (Lyra), Greyed Lavender, Lavender, Deco Pink. Repeat burnishing with White and the colors in this step as necessary. Sharpen edges of dark petals with Lavender (Verithin) and edges of light petals with White (Verithin).

5 Layer dark values with French Grey 90%. Layer Olive Black (Pablo), Olive Green, Cedar Green (Lyra), Green Ochre (Pablo). Lightly burnish light values with Cream. Burnish with Green Ochre (Pablo). Burnish with Olive Black (Pablo), Olive Green, Cedar Green (Lyra). Repeat burnishing with Green Ochre (Pablo), Olive Black (Pablo), Olive Green, Cedar Green (Lyra) as necessary. Sharpen edges with Olive Green (Verithin).

Hyacinth

Another View by **Sue Brooks**

5 Layer highlights with Blue Slate, Cloud Blue, White. Lightly burnish rims with Blue Slate.

4 Lightly layer Smalt Blue (Derwent WS), Blue Violet Lake (Derwent WS), Spectrum Blue (Derwent WS), True Blue, Lilac.

2 Layer outside with Light Blue (Derwent WS). Burnish with colorless blender.

1 Layer edges with Blue Slate. Burnish with colorless blender.

3 Layer inside and shadows with Indigo Blue, Violet Blue. Burnish with colorless blender. Repeat steps 1–3.

6 Layer lavender areas with Mulberry.

8 Burnish with True Blue.

7 Lightly burnish shadows with Indigo Blue, Violet Blue.

9 Lightly burnish rims with Blue Slate, Cloud Blue, White. Sharpen edges with Indigo Blue (Verithin).

Color Palette

Blue Slate	True Blue
Light Blue (Derwent WS)	Lilac
Indigo Blue	Cloud Blue
Violet Blue	White
Smalt Blue (Derwent WS)	Mulberry
Blue Violet Lake (Derwent WS)	Indigo Blue (Verithin)
Spectrum Blue (Derwent WS)	

80 *Creating Radiant Flowers in Colored Pencil*

Iris

Reference photo

4 Gently dab purple areas with Bestine and a small brush. Randomly burnish with White.

11 Layer bottom of bud with Light Umber. Burnish with Sepia, Dark Umber, Light Umber, French Grey 10%.

10 Burnish top of bud with Black Grape and Deep Violet (Spectracolor).

9 Layer bud with Limepeel, Apple Green, French Grey 20%, Zinc Yellow (Lyra). Wash with Bestine and a cotton swab. Burnish light values with White and dark values with French Grey 10%. Lightly burnish Limepeel, Apple Green, Zinc Yellow (Lyra).

5 Burnish with Violet and Purple using same strokes as in step 3. Burnish center with Sunburst Yellow.

6 Drag color into white areas with a dry cotton swab.

7 Lightly stipple spotted variegations with Purple.

8 Draw veins and sharpen edges with Violet (Verithin).

3 Lightly layer dark values with Black Grape using short, stippling strokes that start at the outer edge of the petal and follow its contour. Layer Deep Violet (Spectracolor), Violet, Purple.

2 Impress short strokes to center with Yellow Ochre (Verithin), using heavy pressure. Fill in with Purple (Verithin).

1 Lightly layer Cool Grey 20%, Cream, Zinc Yellow (Lyra). Wash with Bestine and a cotton swab. Layer Cool Grey 20%. Wash with Bestine and a cotton swab.

14 Layer leaves with Olive Green (dark values only), Limepeel, Apple Green, True Green.

15 Burnish dark values with Limepeel and light values with Cream. Sharpen dark edges with Olive Green (Verithin) and light edges with Light Green (Verithin).

13 Layer Terra Cotta, Light Umber, Hazel (Pablo), Sepia. Lightly burnish Jasmine, Cream, French Grey 20%, Hazel (Pablo). Draw veins with Light Umber.

12 Layer dark values of stems with Olive Green. Layer True Green, Apple Green, Limepeel. Burnish with French Grey 20%. Burnish dark values with Olive Green. Burnish with Apple Green, Limepeel.

Color Palette

Cool Grey 20%	Apple Green
Cream	French Grey 10%
Zinc Yellow (Lyra)	French Grey 20%
Yellow Ochre (Verithin)	Light Umber
	Dark Umber
Purple (Verithin)	Sepia
Black Grape	Olive Green
Deep Violet (Spectracolor)	True Green
	Terra Cotta
Violet	Hazel (Pablo)
Purple	Jasmine
Sunburst Yellow	Olive Green (Verithin)
White	
Violet (Verithin)	Light Green (Verithin)
Limepeel	

Lily

Color Palette

Pink Rose
Pink
Raspberry
Tuscan Red
Greyed Lavender
Black Grape
White
Indigo Blue (Verithin)
Tuscan Red (Verithin)
Process Red
Yellow Chartreuse
Limepeel
Olive Green
Dark Green
Cream

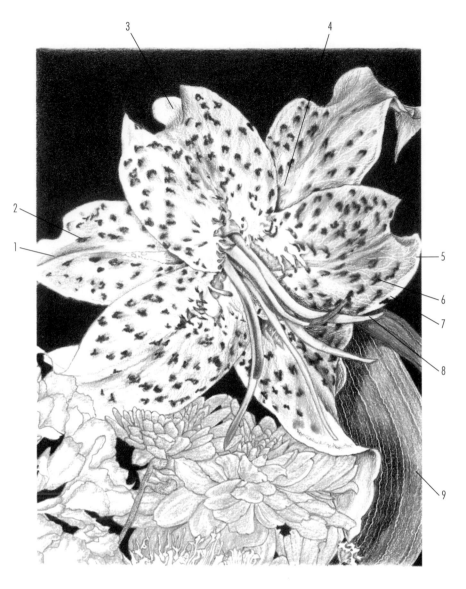

Petals

1 Lightly layer Pink Rose, Pink, Raspberry, Tuscan Red.

2 Layer freckles with Tuscan Red, Raspberry. Layer around freckles with Pink.

3 Impress veins with 7H graphite pencil and drafting or tracing paper. Do not impress lines over freckles. Lightly layer next to impressed line with Greyed Lavender, Black Grape. Layer shadows with Greyed Lavender, using linear strokes.

4 Lightly layer green area with Yellow Chartreuse, Limepeel, Olive Green. Lightly layer shadows with Tuscan Red.

5 Burnish with White, except green area. Burnish with Pink Rose, Pink.

6 Drag pigment from freckles into surrounding area with fine point colorless blender. Lightly layer outer area with Process Red. Burnish inside freckles with Indigo Blue (Verithin).

7 Sharpen edges with Indigo Blue (Verithin) or Tuscan Red (Verithin).

Pistils and Stamen

8 Layer shadows with Greyed Lavender. Layer Tuscan Red (Verithin), Olive Green, Yellow Chartreuse, Limepeel. Burnish with White. Burnish with Olive Green, Yellow Chartreuse, Limepeel. Burnish shadows with Black Grape, Indigo Blue (Verithin).

Leaves

9 Layer Yellow Chartreuse. Impress veins with 7H graphite pencil and drafting or tracing paper. Layer Limepeel, Olive Green, Dark Green. Burnish with Cream. Repeat layering Limepeel, Olive Green, Dark Green. Randomly lift off areas with a small piece of kneaded eraser by stamping surface. Lightly burnish shadows with Black Grape, Indigo Blue (Verithin). Sharpen edges with Indigo Blue (Verithin) or Tuscan Red (Verithin).

Lupine

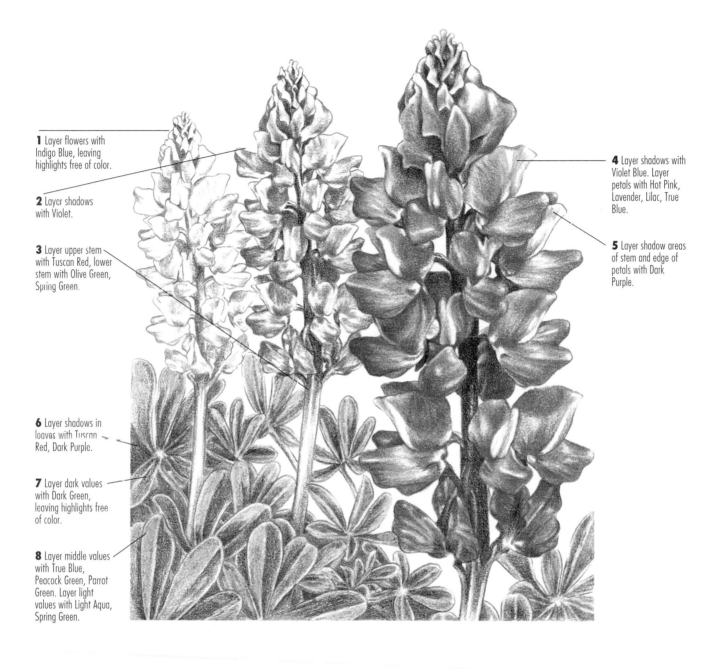

1 Layer flowers with Indigo Blue, leaving highlights free of color.

2 Layer shadows with Violet.

3 Layer upper stem with Tuscan Red, lower stem with Olive Green, Spring Green.

4 Layer shadows with Violet Blue. Layer petals with Hot Pink, Lavender, Lilac, True Blue.

5 Layer shadow areas of stem and edge of petals with Dark Purple.

6 Layer shadows in leaves with Tuscan Red, Dark Purple.

7 Layer dark values with Dark Green, leaving highlights free of color.

8 Layer middle values with True Blue, Peacock Green, Parrot Green. Layer light values with Light Aqua, Spring Green.

Color Palette

Indigo Blue	True Blue
Violet	Dark Purple
Tuscan Red	Spring Green
Olive Green	Dark Green
Hot Pink	Peacock Green
Lavender	Parrot Green
Lilac	Light Aqua
Violet Blue	

Magnolia

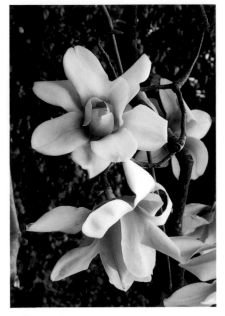

Reference photo

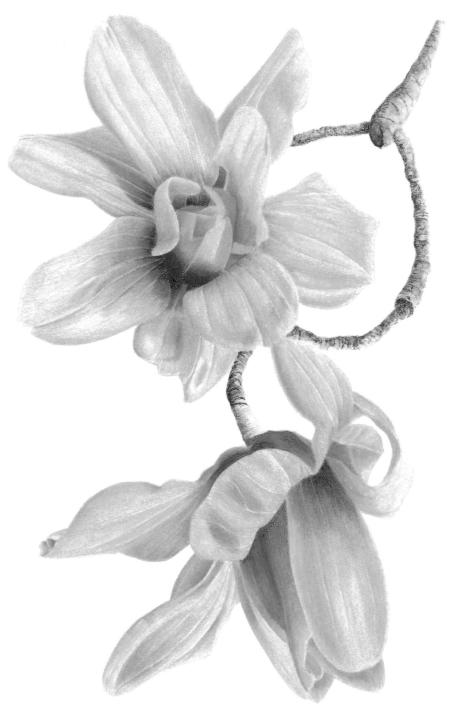

Color Palette
Tuscan Red
Henna
Cinnamon (Lyra)
Clay Rose
Rosy Beige
Pink Rose
Magenta
Process Red
Hot Pink
Pink
Deco Peach
Deco Pink
White
Olive Green
Limepeel
Brownish Beige (Supracolor)
Burnt Umber (Derwent WS)
Dark Umber

Flower

1 Layer shadows with Tuscan Red, Henna, Cinnamon (Lyra). Wash with Bestine and a medium-small brush.

2 Layer dark values with Clay Rose, Rosy Beige, Pink Rose. Wash with Bestine and a medium-small brush.

3 Layer Magenta, Process Red, Hot Pink, Pink. Wash with Bestine and a medium-small brush.

4 Layer Deco Peach, Deco Pink. Wash with Bestine and a cotton swab. To finish the flower, burnish shadows with Henna. Then lightly burnish dark values with Pink Rose. Wash with Bestine and a medium-small brush. Lightly burnish magenta areas with Hot Pink. Wash with Bestine and a medium-small brush. Keep repeating this sequence as necessary. Lightly burnish lighter areas with White. Wash with Bestine and a medium-small brush. Burnish with Deco Pink.

Branches

5 Layer Olive Green, Limepeel. Wash with Bestine and a cotton swab.

6 Lightly layer Brownish Beige (Supracolor). Dab with water and a medium-small brush.

7 Lightly layer Burnt Umber (Derwent WS). Dab with water and a medium-small brush.

8 Layer dark values with Dark Umber.

9 Lightly burnish green area with Olive Green, Limepeel.

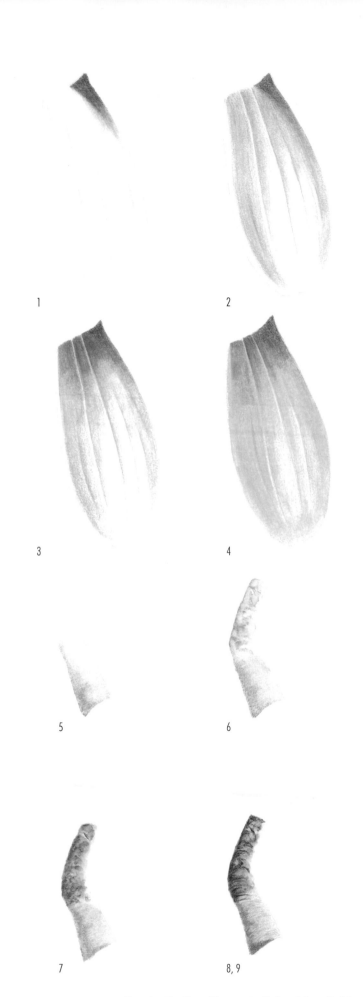

1 2

3 4

5 6

7 8, 9

Marigold

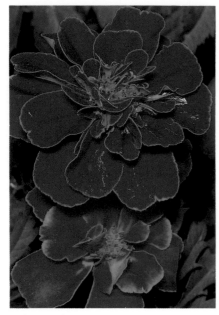

Reference photo

Color Palette

Goldenrod
Spanish Orange
Sunburst Yellow
Canary Yellow (Lyra)
Tuscan Red
Crimson Lake (Spectracolor)
Scarlet Lake
Poppy Red
Yellow Ochre (Verithin)
Olive Black (Pablo)
Olive Green
Grass Green
Limepeel
Cream
Olive Green (Verithin)

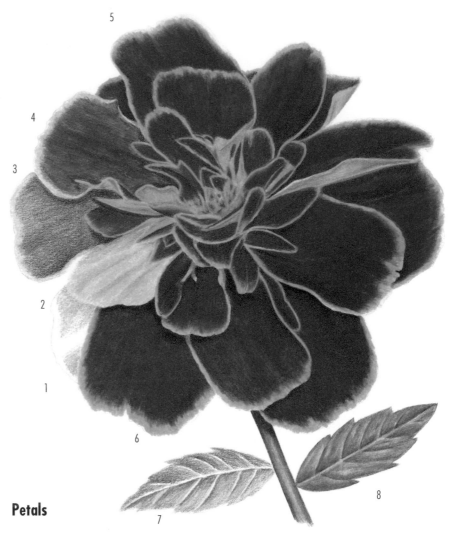

Petals

1 Layer dark values with Goldenrod. Wash with Bestine and a medium-small brush.

2 Layer each petal individually with Goldenrod, Spanish Orange, Sunburst Yellow, Canary Yellow (Lyra). Wash with Bestine and a cotton swab.

3 Layer dark values with Tuscan Red. Layer Crimson Lake (Spectracolor), Scarlet Lake, Poppy Red.

4 Wash with Bestine and a cotton swab.

5 Burnish red areas with Scarlet Lake, Poppy Red. Burnish edges with Goldenrod, Spanish Orange. Sharpen edges with Yellow Ochre (Verithin).

Leaves and Stem

6 Layer dark values with Olive Black (Pablo). Layer Olive Green, Grass Green, Limepeel.

7 Burnish with Cream.

8 Burnish with Olive Green, Grass Green, Limepeel. Sharpen edges with Olive Green (Verithin).

Morning Glory

Petals

1 Layer center with Cool Grey 20%, 10%. Leave paper free of color for pistils. Wash with Bestine and a small brush.

2 Layer Tuscan Red, Dahlia Purple, Mulberry, Process Red using linear strokes.

3 Wash with Bestine and a cotton swab following strokes described in step 2.

4 Layer star area with Process Red, Scarlet Lake. Wash with Bestine and a cotton swab.

5 Burnish with White, except dark values.

6 Lightly burnish with Dahlia Purple, Mulberry. Burnish with Process Red. Blend into center area with White. Sharpen edges with Rose (Verithin).

Leaves

7 Draw veins with Golden Brown (Verithin). Randomly layer Dark Green, Real Green (Spectracolor), Apple Green.

8 Dab with Bestine and a cotton swab.

9 Burnish with White.

10 Lightly burnish with Dark Green, Real Green (Spectracolor), Apple Green. Sharpen edges with Green (Verithin) and Light Green (Verithin).

Color Palette

Cool Grey 10%
Cool Grey 20%
Tuscan Red
Dahlia Purple
Mulberry
Process Red
Scarlet Lake
White
Rose (Verithin)
Golden Brown (Verithin)
Dark Green
Real Green (Spectracolor)
Apple Green
Green (Verithin)
Light Green (Verithin)

Nasturtium

2 Layer Deep Cadmium (Derwent WS). Wipe off excess water before applying and wash with water and a medium brush.

1 Layer center with Raw Sienna (Derwent WS). Wash with water and a medium brush, wiping off excess water.

Color Palette

Raw Sienna (Derwent WS)
Deep Cadmium (Derwent WS)
Spectrum Orange (Derwent WS)
Tuscan Red
Crimson Lake (Spectracolor)
Crimson Red
Poppy Red
Pale Vermilion
Tuscan Red (Verithin)
Scarlet Red (Verithin)
Vermilion (Verithin)
Yellow Ochre (Verithin)
Light Umber
Goldenrod
Canary Yellow
Canary Yellow (Verithin)
Straw Yellow (Derwent WS)
Olive Yellow (Pablo)
Olive Black (Pablo)

5 Gently erase light values with a kneaded eraser.

4 With a small amount of water, lightly wash step 3 with a cotton swab.

3 Layer Spectrum Orange (Derwent WS). Wipe off excess water before applying and wash with water and a medium brush.

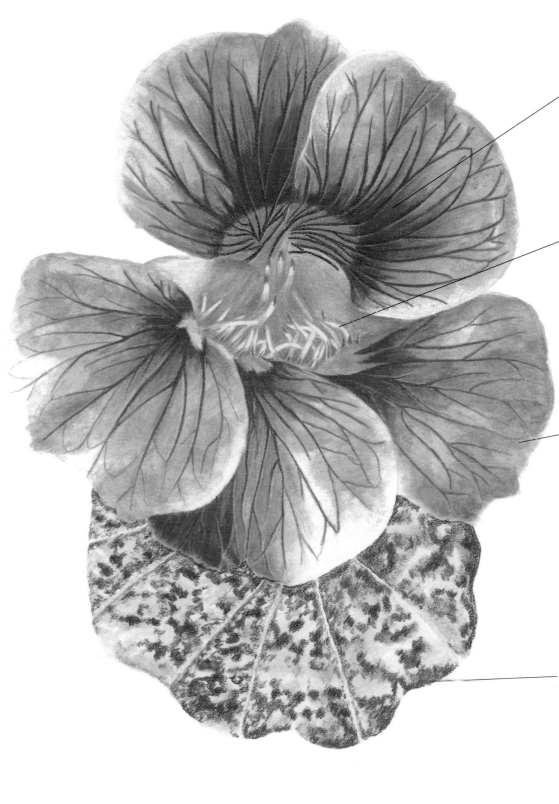

6 Layer variegations with Tuscan Red, Crimson Lake (Spectracolor), Crimson Red, Poppy Red, Pale Vermilion. Lightly wash with Bestine and a small brush. Burnish with Tuscan Red (Verithin), Scarlet Red (Verithin), Vermilion (Verithin), Yellow Ochre (Verithin).

7 Erase center area with sharpened imbibed eraser strip in an electric eraser. Burnish surrounding area with Light Umber, Goldenrod, creating stamen shapes. Lightly wash with Bestine and a small brush. Burnish stamen with Canary Yellow, Crimson Red.

8 Sharpen edges and variegations with Crimson Red, Vermilion (Verithin), Yellow Ochre (Verithin) or Canary Yellow (Verithin).

9 Layer leaf with Straw Yellow (Derwent WS). Wash with water and a medium brush. Randomly layer with Olive Yellow (Pablo). Wash with Bestine and a medium brush. Randomly layer and burnish with Olive Black (Pablo). Dab with Bestine and a cotton swab, dabbing color into lighter areas. Repeat layering and burnishing with Olive Black (Pablo), dabbing with Bestine as necessary.

Creating Radiant Flowers in Colored Pencil 89

Orchid—Lady's Slipper

Reference photo

Color Palette

French Grey 10%
French Grey 20%
French Grey 30%
French Grey 50%
Cream
Apple Green
Olive Yellow (Pablo)
Raspberry
Henna
Light Umber
Olive Green
Mulberry
Magenta
Tuscan Red (Verithin)
Olive Green (Verithin)
Zinc Yellow (Lyra)
Warm Grey 90%
Limepeel

Petals

1 Layer top edge of vertical petal with French Grey 50% and 20%. Wash with Bestine and a cotton swab. Burnish with French Grey 10%.

2 Layer bottom of vertical petal and to horizontal petals with Cream. Wash with Bestine and a cotton swab.

3 Layer upper portion of horizontal petals with Apple Green, Olive Yellow (Pablo). Wash with Bestine and a cotton swab.

4 Layer horizontal petals with Raspberry, Henna, Light Umber. Wash with Bestine and a cotton swab.

5 Layer Raspberry, Henna, Light Umber. Lightly burnish with Cream.

6 Draw variegations on horizontal petals with Apple Green and Raspberry.

7 Draw green variegations on lower part of vertical petal with Olive Green and Apple Green. Lightly layer between variegations with Apple Green. Wash with Bestine and a medium-small brush. Lightly burnish with Cream.

8 Draw dark red variegations with Tuscan Red (Verithin). Layer between variegations with Mulberry and Magenta, then drag into green area with a dry cotton swab. Lightly wash with Bestine and medium-small brush. Burnish red and green variegations of vertical petal with Tuscan Red (Verithin) and Olive Green (Verithin).

9 Burnish dark red area at top of horizontal petals with Tuscan Red (Verithin). Add hairs with sharp Tuscan Red (Verithin). Sharpen hairs with Tuscan Red (Verithin).

Center

10 Layer with Zinc Yellow (Lyra), Cream. Wash with Bestine and a cotton swab. Layer shadows with French Grey 30%, 20%. Lightly layer Henna; smudge with a dry cotton swab. Wash with Bestine and a small brush.

11 Add details with Tuscan Red (Verithin), Warm Grey 90%, Olive Green.

Lower Petal

12 Layer dark values with Tuscan Red (Verithin). Layer Raspberry, Henna. Wash with Bestine and a cotton swab. Lightly erase with a kneaded eraser. Lightly burnish with Raspberry, Henna.

13 Draw veins and sharpen edges with Tuscan Red (Verithin).

Stem

14 Layer Olive Green, Limepeel. Burnish with French Grey 10%. Burnish Olive Green, Limepeel.

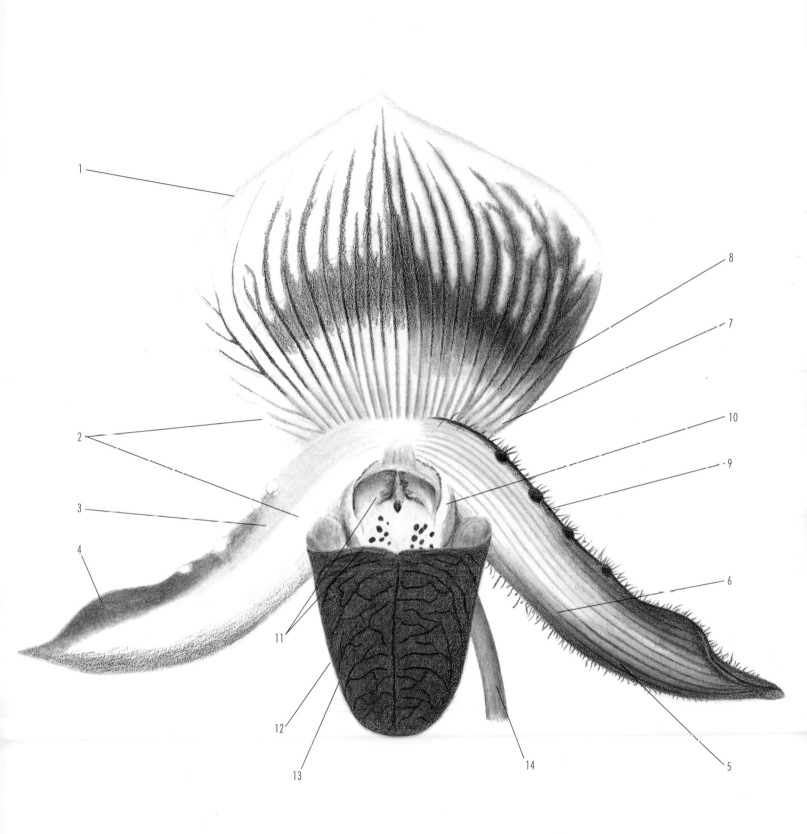

1

8

7

2

10

3

9

4

6

11

12

5

13

14

Orchid—Hybrid

Reference photo—flower

Reference photo—leaf

Color Palette

Sunburst Yellow
Canary Yellow
Cream (Lyra)
White
Crimson Red
Light Grey (Verithin)
Tuscan Red
Crimson Lake (Spectracolor)
Magenta
Process Red
Carmine Red (Verithin)
Magenta (Verithin)
French Grey 50%
French Grey 10%
Olive Green
Apple Green (Lyra)
Olive Green (Verithin)
Light Green (Verithin)

Center

1 Burnish radial patterns and darker yellow areas with Sunburst Yellow.

2 Layer Canary Yellow, Cream (Lyra).

3 Lightly burnish with White. Burnish with Canary Yellow, Cream (Lyra).

4 Layer ends of radial patterns with Crimson Red. Burnish center area with Crimson Red.

5 Lightly burnish center white area with Light Grey (Verithin).

Petals

6 Layer shadows with Tuscan Red.

7 Lightly burnish veins with Crimson Lake (Spectracolor), Crimson Red.

8 Layer with overlapping gradations of Crimson Red, Magenta, Process Red, leaving white areas free of color.

9 Burnish with White, except white areas, shadows and veins.

10 Burnish with overlapping gradations of Crimson Red, Magenta, Process Red, except white areas. Sharpen edges with Carmine Red (Verithin) or Magenta (Verithin), depending on corresponding color.

Leaf and Stem

11 Layer shadows with French Grey 50%.

12 Layer Olive Green, using heavier application to right side of leaf; layer Apple Green (Lyra).

13 Lightly burnish left side of leaf with Cream (Lyra) and right side of leaf with French Grey 10%.

14 Lightly burnish left side of leaf with Apple Green (Lyra) and right side of leaf with Olive Green. Repeat steps 13 and 14 as necessary. Sharpen dark edges with Olive Green (Verithin) and light edges with Light Green (Verithin).

More Orchids

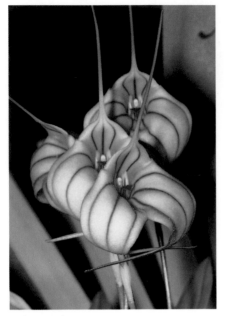

Reference photo

Color Palette

French Grey 10%
French Grey 20%
French Grey 50%
French Grey 70%
Terra Cotta
Pumpkin Orange
Spanish Orange
Sunburst Yellow
Cream (Lyra)
Mulberry
Magenta
Crimson Red
White
Goldenrod
Golden Brown
 (Verithin)
Tuscan Red
Henna
Tuscan Red
 (Verithin)
Olive Green (Lyra)
Olive Green
Apple Green (Lyra)
Cream
Olive Green
 (Verithin)

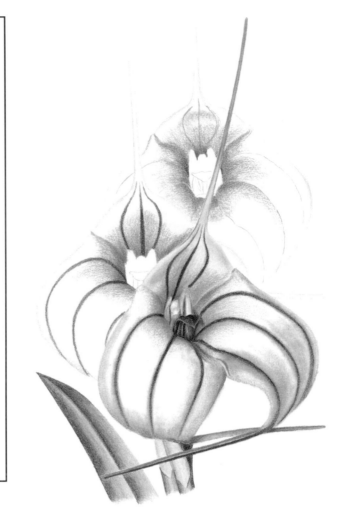

Petals

1 Layer light shadows with French Grey 20%, 10%. Wash with Bestine and a cotton swab.

2 Lightly layer dark shadows with French Grey 70% and Terra Cotta. Layer from center with overlapping gradations of Pumpkin Orange, Spanish Orange, Sunburst Yellow, Cream (Lyra). Smudge with a dry cotton swab.

3 Lightly burnish with Pumpkin Orange, Spanish Orange, Sunburst Yellow, Cream (Lyra).

4 Layer variegations from center with overlapping gradations of Mulberry, Magenta, Crimson Red. Smudge with a dry cotton swab.

5 On separate sheet of paper, heavily burnish Magenta and Crimson Red. Pick up pigment with a dry cotton swab and apply to create light pink areas. Save cotton swab. Lightly burnish dark values with White or French Grey 10%.

6 Layer shadows in long petal "extensions" with French Grey 50%. Layer Goldenrod, Spanish Orange. Layer bottom extension with Magenta. Burnish with French Grey 20%, Goldenrod. Sharpen edges with Golden Brown (Verithin).

Center

7 Lightly layer white center area with French Grey 50%. With cotton swab used in step 5, apply pigment to this area. Lightly burnish variegations with Magenta, Crimson Red.

8 Layer dark values with Tuscan Red. Layer dark red center area with Henna. Burnish with French Grey 20%, Henna. Sharpen edge with Tuscan Red (Verithin).

Leaf and Stems

9 Layer shadows with French Grey 70%. Layer Olive Green (Lyra), Olive Green, Apple Green (Lyra). Lightly burnish with Cream, Olive Green, Apple Green (Lyra). Burnish light stem area with French Grey 10%. Sharpen edges with Olive Green (Verithin).

Orchid—Cymbidium

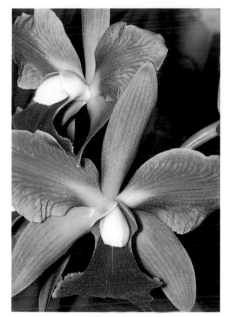

Reference photo

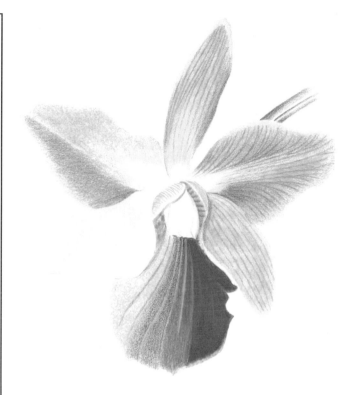

Color Palette

French Grey 10%
French Grey 20%
French Grey 30%
Olive Yellow
 (Pablo)
Zinc Yellow
 (Lyra)
Pale Yellow
 (Pablo)
Goldenrod
Hazel (Pablo)
Terra Cotta
Process Red
Deco Orange
Magenta
Deco Pink
White
Rose (Verithin)
Olive Green
Apple Green
Olive Green
 (Verithin)
Light Green
 (Verithin)

Petals

1 Layer shadows with French Grey 30%. Wash with Bestine and a cotton swab.

2 Layer Olive Yellow (Pablo), Zinc Yellow (Lyra), Pale Yellow (Pablo). Wash with Bestine and a cotton swab.

3 Layer edge of petal with Goldenrod, allowing underpainting from step 2 to show through. Wash with Bestine and a cotton swab.

4 Layer Hazel (Pablo), using strokes that follow contours. Layer dark values with Terra Cotta.

5 Layer variegations with Process Red.

Magenta Petal

6 Layer petal and inside center with Deco Orange. Wash with Bestine and a cotton swab.

7 Layer dark values with Magenta. Layer Process Red.

8 Burnish with White.

9 Burnish dark values with Magenta, except edge of petal. Burnish with Process Red. Sharpen edge with Rose (Verithin).

10 Burnish edge with White.

Center

11 Layer white center petals with Pale Yellow (Pablo), French Grey 20%, 10%. Burnish with White.

12 Lightly burnish variegations inside center with Process Red. Lightly burnish with Deco Orange, White.

13 Draw variegations outside of left center petal with Deco Pink.

14 Layer French Grey 20% outside of right center petal. Wash with Bestine and a cotton swab.

15 Layer with Deco Pink. Burnish with French Grey 10%, White.

Vine

16 Lightly burnish with Olive Green, Apple Green, leaving highlights free of color. Sharpen edges with Olive Green (Verithin) or Light Green (Verithin).

Pansy

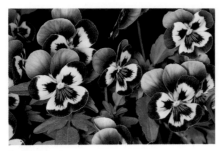

Reference photo

Color Palette

- Jasmine
- Cream
- Spanish Orange
- Sunburst Yellow
- Canary Yellow
- Canary Yellow (Spectracolor)
- Light Chrome (Lyra)
- White
- French Grey 20%
- French Grey 10%
- Warm Grey 90%
- Black Grape
- Violet
- Purple
- Tuscan Red
- Imperial Violet
- Juniper Green (Lyra)
- Olive Green
- Limepeel
- Olive Green (Verithin)

Petals

1 Outline perimeter of pansy, then layer with Jasmine, Cream. Wash with Bestine and a cotton swab.

2 Layer Spanish Orange, Sunburst Yellow, Canary Yellow. Wash with Bestine and a cotton swab.

3 Burnish yellow areas not to be covered by purple with Sunburst Yellow (bottom petal only), Canary Yellow, Canary Yellow (Spectracolor), Light Chrome (Lyra), White. Burnish shadows and center with French Grey 20%, 10%. Burnish dark variegations with Warm Grey 90%, Black Grape. Randomly layer purple areas with Black Grape, Violet, Purple, Tuscan Red. Randomly burnish purple areas on petal tips with White. Burnish lighter inner portions with Cream and inner edges with Light Chrome (Lyra). Burnish bottom petal with Violet, Purple, Tuscan Red. Randomly burnish purple areas at center of petals with White, Purple, Tuscan Red. Burnish dark variegations with Black Grape.

4 Layer violet petals with Black Grape, Violet, Purple, Imperial Violet. Smudge lighter areas of petals with a dry cotton swab. Layer dark areas with Black Grape, Violet, Purple. Burnish smudged areas and top of dark area with White. Burnish dark areas with Black Grape, Violet, Purple. Repeat burnishing with White, Black Grape, Violet and Purple as necessary.

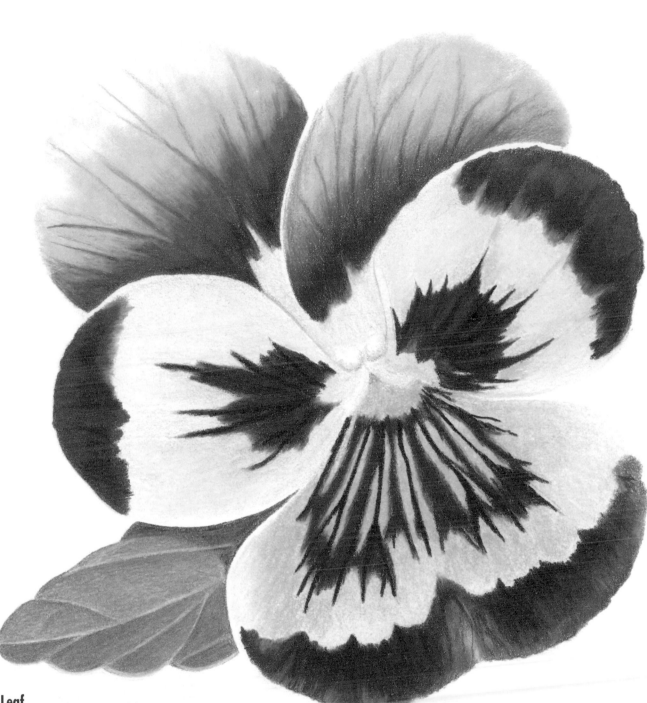

Leaf

5 Layer shadows with Warm Grey 90% and dark values with Juniper Green (Lyra). Layer Olive Green, Limepeel. Lightly burnish dark values with Limepeel and light values with Cream. Burnish dark values with Olive Green and light values with Limepeel. Sharpen edges with Olive Green (Verithin).

Passion Flower

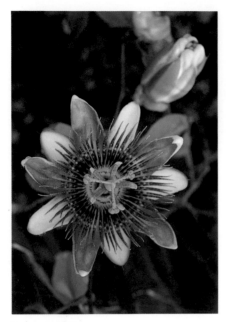

Reference photo

Color Palette

French Grey 10%
French Grey 20%
French Grey 30%
Light Green (Lyra)
Cream
Lavender
Greyed Lavender
Rosy Beige
Pink Rose
Olive Green
Olive Green (Verithin)
Spanish Orange
Yellow Ochre (Verithin)
Black Grape
Violet
White
White (Verithin)
Violet (Verithin)
Lavender (Verithin)
Olive Yellow (Pablo)
Cool Grey 90%
Juniper Green (Lyra)
Grass Green
Apple Green
Light Green (Verithin)
Tuscan Red

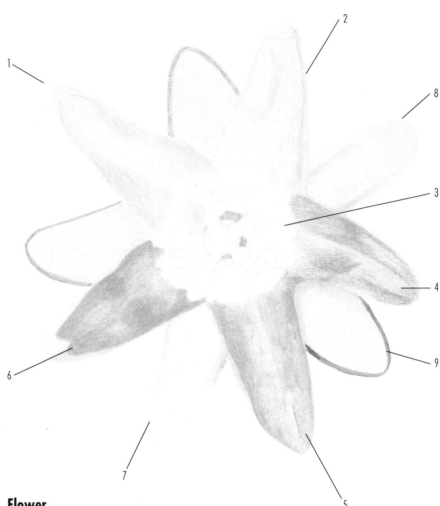

Flower

1 Layer dark values with French Grey 20%, 10%.

2 Wash with Bestine and a medium brush.

3 Layer center green area (not including pistils) with Light Green (Lyra), French Grey 20%. Wash with Bestine and a medium-small brush. Lightly burnish with Light Green (Lyra).

4 Layer lavender petals with Lavender, Greyed Lavender, Rosy Beige, Pink Rose.

5 Wash with Bestine and a medium-small brush.

6 Lightly burnish with Lavender, Greyed Lavender, Rosy Beige, Pink Rose.

7 Layer white petals with French Grey 30%, 20%, 10%.

8 Wash with Bestine and a medium-small brush.

9 Layer green-edged white petals with Olive Green. Burnish with French Grey 10%. Sharpen edges with Olive Green (Verithin).

10 Burnish yellow areas of pistils with Spanish Orange. Sharpen edges with Yellow Ochre (Verithin).

11 Burnish thin petals with Black Grape, Violet, Lavender, leaving small highlight area free of color. Burnish all except dark area with White, dragging color into highlight area. Burnish with Violet (Verithin) and Lavender (Verithin). Sharpen dark edges with Violet (Verithin) and light edges with White (Verithin).

12 Layer pistils with Olive Green (Verithin), Olive Yellow (Pablo), Light Green (Lyra). Lightly burnish lighter areas with White. Stipple with Violet (Verithin).

13 Burnish variegations in center with Violet (Verithin).

Leaves and Stem

14 Layer shadows with Cool Grey 90%. Layer Juniper Green (Lyra), Grass Green, Apple Green.

15 Dab with Bestine and a medium-small brush.

16 Burnish with Cream, except darkest values.

17 Burnish Grass Green, Apple Green. Sharpen edges with Light Green (Verithin).

18 Repeat steps 15–17 for stem, adding Tuscan Red to the layering sequence described in step 15.

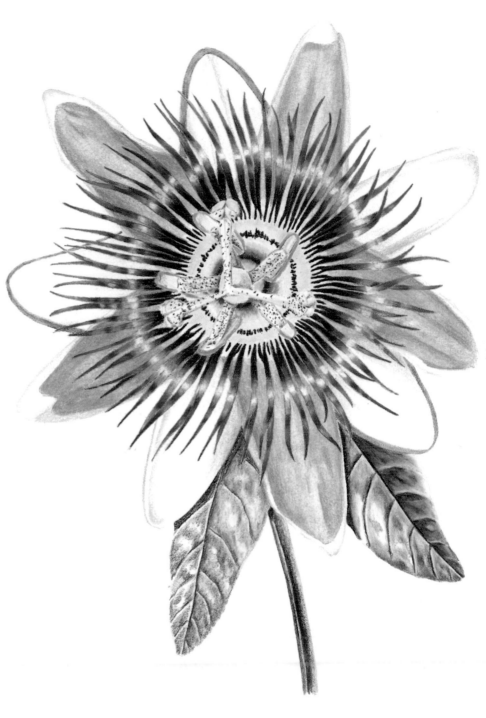

Peony

Reference photo

Color Palette

Crescent mat board, Williamsburg Green

White
Blush Pink
Indigo Blue
Black Grape
Magenta
Hot Pink
Crimson Lake (Spectracolor)

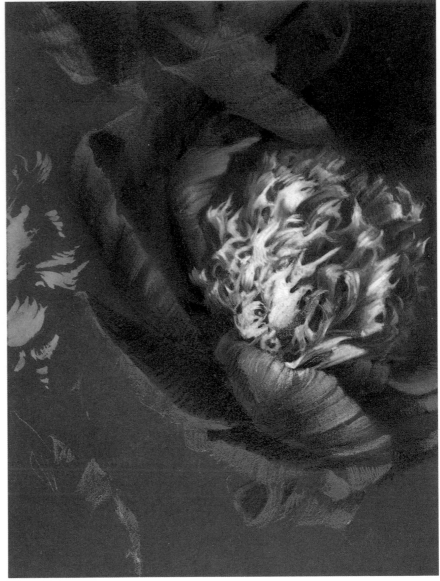

Center

1 Lay out with White.

2 Brush highlights with bleach, using a soft brush with light strokes.

3 Lightly layer highlights with White (heavier in bleached area), Blush Pink.

4 Layer shadows with Indigo Blue, Black Grape. Burnish with Magenta.

Petals

5 Lightly layer highlights with White, Hot Pink. Lightly layer Magenta, Crimson Lake (Spectracolor), leaving paper free of color for shadows. Burnish with cheesecloth.

6 Layer shadows with Indigo Blue, Black Grape. Burnish with cheese-cloth.

Petunia With Dusty Miller

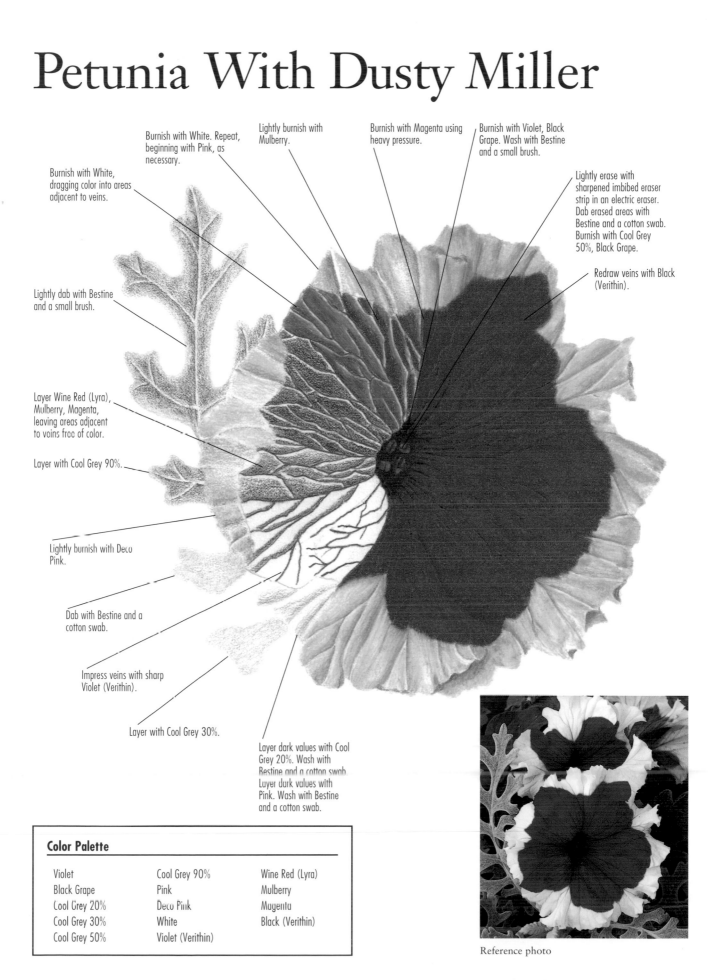

Burnish with White, dragging color into areas adjacent to veins.

Burnish with White. Repeat, beginning with Pink, as necessary.

Lightly burnish with Mulberry.

Burnish with Magenta using heavy pressure.

Burnish with Violet, Black Grape. Wash with Bestine and a small brush.

Lightly erase with sharpened imbibed eraser strip in an electric eraser. Dab erased areas with Bestine and a cotton swab. Burnish with Cool Grey 50%, Black Grape.

Redraw veins with Black (Verithin).

Lightly dab with Bestine and a small brush.

Layer Wine Red (Lyra), Mulberry, Magenta, leaving areas adjacent to veins free of color.

Layer with Cool Grey 90%.

Lightly burnish with Deco Pink.

Dab with Bestine and a cotton swab.

Impress veins with sharp Violet (Verithin).

Layer with Cool Grey 30%.

Layer dark values with Cool Grey 20%. Wash with Bestine and a cotton swab. Layer dark values with Pink. Wash with Bestine and a cotton swab.

Color Palette

Violet	Cool Grey 90%	Wine Red (Lyra)
Black Grape	Pink	Mulberry
Cool Grey 20%	Deco Pink	Magenta
Cool Grey 30%	White	Black (Verithin)
Cool Grey 50%	Violet (Verithin)	

Reference photo

Petunia

*Another View by **Edna Henry***

Color Palette

All colors are Lyra Rembrandt Polycolor unless otherwise noted.

Pink Madder Lake
Zinc Yellow
Lavender (Prismacolor)
White (Prismacolor)
Violet
Rose Madder Lake
Magenta
Purple (Prismacolor)
Cream
Light Green
Light Blue
Moss Green
Aquamarine
Emerald Green
Peacock Blue
Hooker's Green
Apple Green

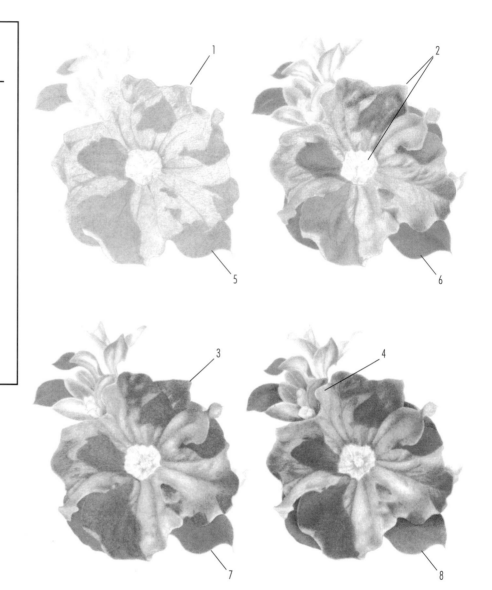

Flower

1 Layer Pink Madder Lake, adding more layers in shadow areas. Layer center with Zinc Yellow, Light Green.

2 Layer Lavender (Prismacolor). Lightly burnish with White (Prismacolor). Layer darker values with Violet.

3 Layer Rose Madder Lake, Magenta. Layer shadows with Purple (Prismacolor).

4 Lighten highlights with kneaded eraser.

Leaves

5 Layer Cream, Zinc Yellow, Light Green. Layer shadows with Light Blue, Moss Green.

6 Layer Aquamarine, Emerald Green. Layer shadows with Peacock Blue.

7 Layer Peacock Blue, Pink Madder Lake. Layer shadows with Hooker's Green, Apple Green.

8 Lightly layer shadows with Pink Madder Lake, Purple (Prismacolor).

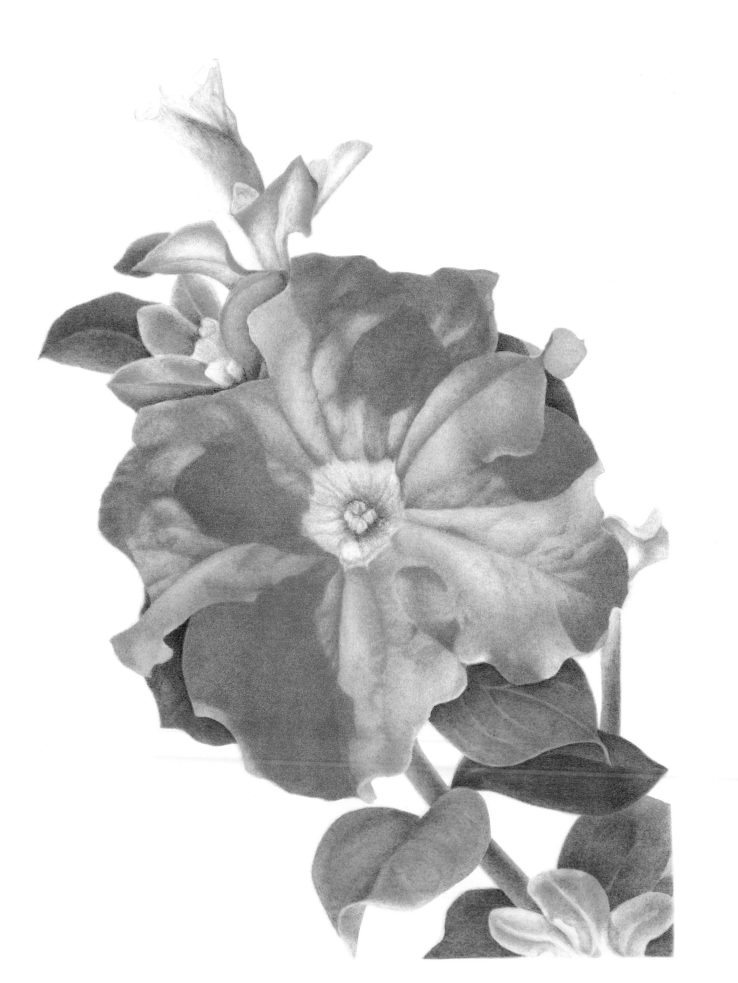

Poinsettia

Another View by **Sherry Loomis**

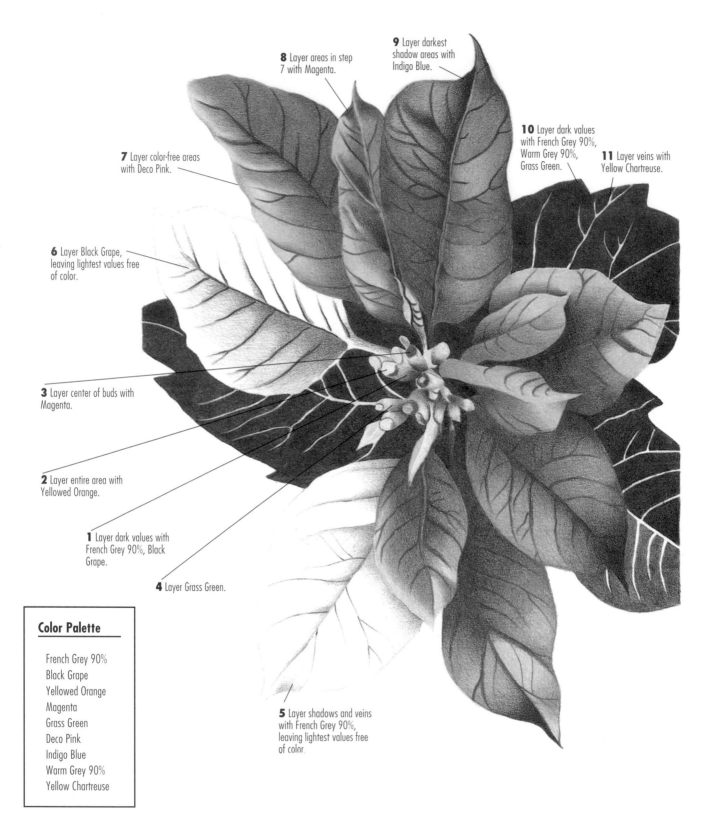

8 Layer areas in step 7 with Magenta.

9 Layer darkest shadow areas with Indigo Blue.

10 Layer dark values with French Grey 90%, Warm Grey 90%, Grass Green.

11 Layer veins with Yellow Chartreuse.

7 Layer color-free areas with Deco Pink.

6 Layer Black Grape, leaving lightest values free of color.

3 Layer center of buds with Magenta.

2 Layer entire area with Yellowed Orange.

1 Layer dark values with French Grey 90%, Black Grape.

4 Layer Grass Green.

5 Layer shadows and veins with French Grey 90%, leaving lightest values free of color.

Color Palette

French Grey 90%
Black Grape
Yellowed Orange
Magenta
Grass Green
Deco Pink
Indigo Blue
Warm Grey 90%
Yellow Chartreuse

Poppy

Color Palette

Tuscan Red
Crimson Red
Scarlet Lake
Poppy Red
White
Black
Black (Verithin)
Tuscan Red (Verithin)
Crimson Lake (Spectracolor)
Carmine Red (Verithin)
Vermilion (Verithin)
French Grey 90%
French Grey 70%
French Grey 20%
French Grey 10%
Cool Grey 90%
Dark Green
Olive Green
Apple Green
Limepeel
Yellow Chartreuse
Cream
Olive Green (Verithin)
Light Green (Verithin)

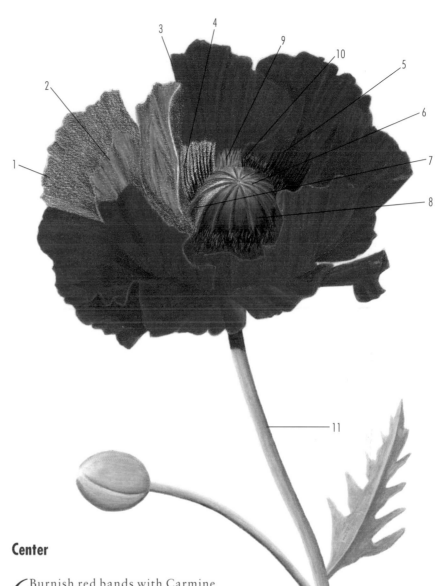

Petals

1 Layer shadows with Tuscan Red. Layer Crimson Red, Scarlet Lake, Poppy Red.

2 Burnish with White, except shadows and dark values.

3 Burnish with Crimson Red, Scarlet Lake, Poppy Red. Repeat burnishing as necessary.

4 Layer Black, Tuscan Red. Burnish with Black (Verithin), Tuscan Red (Verithin) over black variegations only.

5 Burnish with Crimson Lake (Spectracolor), Crimson Red. Sharpen edges with Carmine Red (Verithin) or Vermilion (Verithin).

Center

6 Burnish red bands with Carmine Red (Verithin) and Vermilion (Verithin).

7 Layer gradation of French Grey 90%, 70%, 20%.

8 Burnish with French Grey 10%. Burnish with French Grey 90%, 70%, 20%. Repeat as necessary.

9 Carefully scrape with a new #11 X-Acto knife blade.

10 Draw the stamen with Black (Verithin), leaving some scraped areas free of color.

Leaf, Stem and Bud

11 Layer shadows with Cool Grey 90%. Layer Dark Green, Olive Green, Apple Green, Limepeel, Yellow Chartreuse. Wash with Bestine and a medium brush. Burnish with Cream. Burnish with Limepeel and Yellow Chartreuse. Sharpen edges with Olive Green (Verithin) or Light Green (Verithin).

Primrose

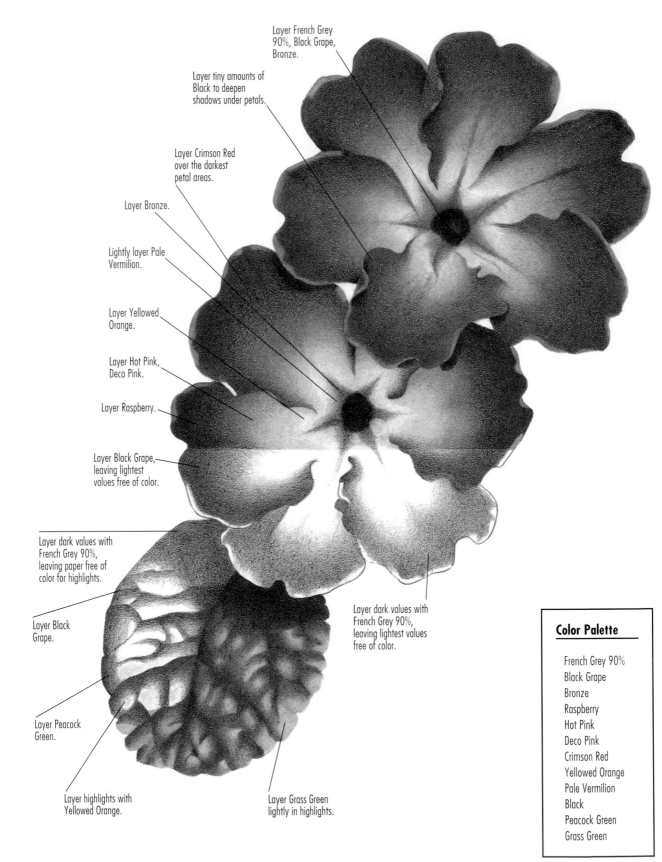

Layer French Grey 90%, Black Grape, Bronze.

Layer tiny amounts of Black to deepen shadows under petals.

Layer Crimson Red over the darkest petal areas.

Layer Bronze.

Lightly layer Pale Vermilion.

Layer Yellowed Orange.

Layer Hot Pink, Deco Pink.

Layer Raspberry.

Layer Black Grape, leaving lightest values free of color.

Layer dark values with French Grey 90%, leaving paper free of color for highlights.

Layer Black Grape.

Layer Peacock Green.

Layer highlights with Yellowed Orange.

Layer dark values with French Grey 90%, leaving lightest values free of color.

Layer Grass Green lightly in highlights.

Color Palette

French Grey 90%
Black Grape
Bronze
Raspberry
Hot Pink
Deco Pink
Crimson Red
Yellowed Orange
Pale Vermilion
Black
Peacock Green
Grass Green

Rhododendron

Reference photo—flowers

Reference photo—leaves

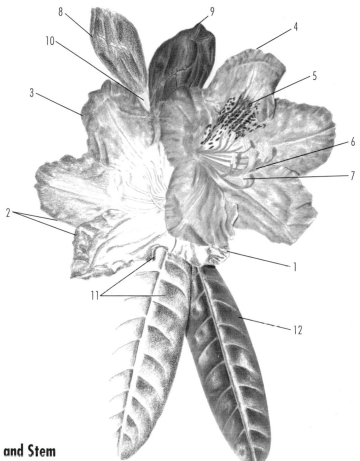

Petals

1 Layer shadows with Cool Grey 50%. Wash with Bestine and a cotton swab or small brush.

2 Layer Process Red, Hot Pink, Deco Pink.

3 Burnish with White.

4 Burnish with Hot Pink, Deco Pink.

5 Burnish variegations with Tuscan Red, Raspberry. Sharpen edges with Rose (Verithin).

Pistil and Stamen

6 Layer Deco Pink, Cool Grey 20%, Olive Yellow (Pablo). Burnish with Pale Yellow (Pablo).

7 Draw details with Light Grey (Verithin).

Buds and Stem

8 Layer Scarlet Lake, Process Red, Hot Pink, Deco Pink.

9 Burnish with White. Burnish with Scarlet Lake, Process Red, Hot Pink, Deco Pink.

10 Layer Olive Yellow (Pablo). Burnish with Pale Yellow (Pablo). Sharpen edges with Rose (Verithin).

Leaf

11 Layer shadows with Cool Grey 90%. Layer Juniper Green (Lyra), Grass Green, Limepeel. Leave highlight areas free of color.

12 Burnish with Pale Yellow (Pablo). Burnish with Juniper Green (Lyra), Grass Green, Limepeel. Sharpen edges with Grass Green (Verithin).

Color Palette

Cool Grey 20%
Cool Grey 50%
Cool Grey 90%
Process Red
Hot Pink
Deco Pink
White
Tuscan Red
Raspberry
Olive Yellow (Pablo)
Pale Yellow (Pablo)
Light Grey (Verithin)
Scarlet Lake
Rose (Verithin)
Juniper Green (Lyra)
Grass Green
Limepeel
Grass Green (Verithin)

Rose

Reference photo

Color Palette

Cool Grey 30%
Cool Grey 90%
Greyed Lavender
Pink Rose
Deco Pink
White
Tuscan Red
Dark Carmine (Lyra)
Light Carmine (Lyra)
Rose Madder Lake (Lyra)
Rose (Verithin)
Pink (Verithin)
Juniper Green (Lyra)
Grass Green
Limepeel
Cream
Green (Verithin)
Light Umber
Tuscan Red (Verithin)

1 Layer shadows in petals with Cool Grey 30%. Wash with Bestine and a cotton swab or small brush in tight areas.

2 Layer dark values with Cool Grey 90%. Layer shadows with Greyed Lavender. Wash with Bestine and a cotton swab or small brush in tight areas.

3 Layer dark values with Pink Rose and light values with Deco Pink. Burnish with White, Pink Rose, Deco Pink.

4 Layer dark pink shadows with Tuscan Red. Layer Dark Carmine (Lyra), Light Carmine (Lyra), Rose Madder Lake (Lyra), Pink Rose.

5 Layer light pink shadows with Tuscan Red. Burnish with Pink Rose. Sharpen edges with Rose (Verithin) or Pink (Verithin).

8 Layer dark values in thorns with Juniper Green (Lyra). Layer Tuscan Red, Light Umber. Burnish with Cream. Lightly burnish Tuscan Red, Light Umber. Sharpen edges with Tuscan Red (Verithin)

6 Layer dark values in leaf and stem with Cool Grey 90%. Layer Juniper Green (Lyra), Grass Green, Limepeel and Tuscan Red on the stem, leaving highlights free of color.

7 Lightly burnish with Cream. Burnish with Juniper Green (Lyra), Grass Green, Limepeel and Tuscan Red on the stem only. Sharpen edges with Green (Verithin).

Rose

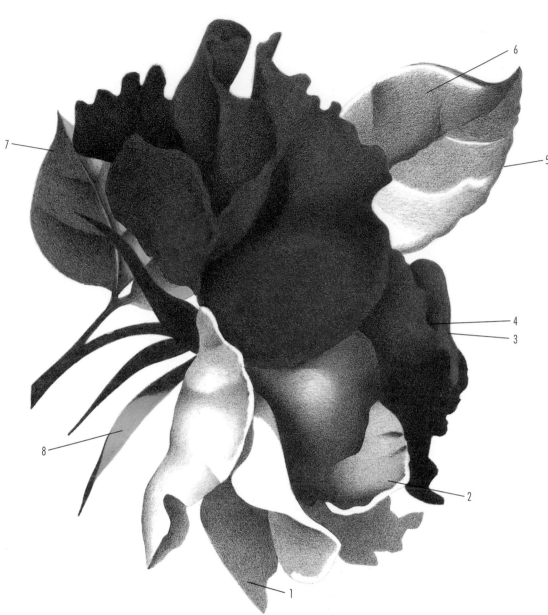

Another View by **Sherry Loomis**

Color Palette

French Grey
90%
Black Grape
Crimson Red
Indigo Blue
Peacock Green
Spring Green

Petals

1 Layer shadows with French Grey 90%, leaving lightest values free of color.

2 Layer Black Grape, leaving lightest values free of color.

3 Layer Crimson Red over entire blossom.

4 Layer darkest shadow areas with Indigo Blue.

Stem and Leaves

5 Layer shadows with French Grey 90%, leaving lightest values free of color.

6 Layer Black Grape, leaving lightest values free of color.

7 Layer dark values with Peacock Green.

8 Layer with Spring Green, slightly overlapping with the edges of areas completed in steps 1–3.

Slipperwort (*Calceolaria*)

Impress veins with White (Verithin), keeping pencil sharp at all times. Layer Apple Green, Limepeel.

Layer Tuscan Red (small amounts in darker values of red variegations). Burnish with Crimson Lake (Spectracolor), Crimson Red. Sharpen edges of variegations with Carmine Red (Verithin) and edges of petals with Yellow Ochre (Verithin).

To begin, layer upper petals with French Grey 10%, 20%, 50%, leaving small areas free of color. Layer Goldenrod. Wash with Bestine and a medium-small brush. Wash lower petals with Bestine and a cotton swab. Lightly layer lower petals with French Grey 20%, Goldenrod, Spanish Orange. Wash with Bestine and a highly saturated medium-small brush.

Continue by layering Sunburst Yellow, Canary Yellow (Lyra). Wash with Bestine and a cotton swab (use a small brush in upper petals). Repeat layering yellows and washing with Bestine as necessary for complete coverage.

Layer Olive Green, Apple Green, Limepeel. Dab with Bestine and a highly saturated medium-small brush. Burnish with Cream, Olive Green, Apple Green, Limepeel. Repeat dabbing with Bestine and burnishing as necessary. Sharpen edges with Light Green (Verithin).

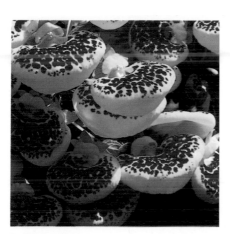

Reference photo

Color Palette

French Grey 50%	Crimson Red
French Grey 20%	Carmine Red (Verithin)
French Grey 10%	Yellow Ochre (Verithin)
Goldenrod	White (Verithin)
Spanish Orange	Apple Green
Sunburst Yellow	Limepeel
Canary Yellow (Lyra)	Olive Green
Tuscan Red	Cream
Crimson Lake (Spectracolor)	Light Green (Verithin)

Salpiglossis (Painted Tongue)

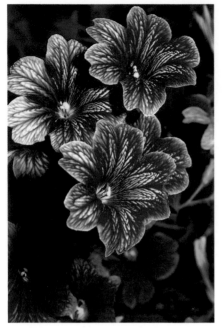

Reference photo

Color Palette

Spanish Orange
Sunburst Yellow
Canary Yellow (Lyra)
Tuscan Red
Crimson Red
Scarlet Lake
Pompeian Red (Lyra)
Pale Geranium Lake (Lyra)
White
Tuscan Red (Verithin)
Olive Black (Pablo)
Olive Green
Apple Green
Cream
Goldenrod
Olive Green (Verithin)

Petals

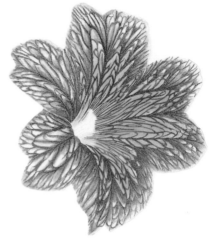

1 Layer Spanish Orange, Sunburst Yellow, Canary Yellow (Lyra). Wash with Bestine and a cotton swab.

2 Layer Tuscan Red, Crimson Red, Scarlet Lake, Pompeian Red (Lyra), Pale Geranium Lake (Lyra). Lightly smudge white areas with dry cotton swab.

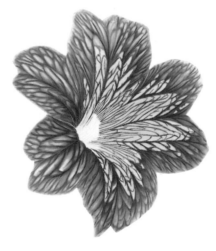

3 Burnish with White.

4 Burnish with Pompeian Red (Lyra). Sharpen dark red areas adjacent to yellow variegations with Tuscan Red (Verithin).

Center

5 Layer Olive Black (Pablo), Olive Green. Lightly burnish stem only with Cream.

6 Lightly burnish with Goldenrod, Canary Yellow (Lyra).

Leaves and Stem

7 Layer Olive Black (Pablo), Olive Green, Apple Green.

8 Using short, light strokes, add cilia with Olive Green (Verithin).

Shasta Daisy

Color Palette

Cool Grey 10%
Cool Grey 20%
Cool Grey 50%
Cool Grey 70%
Goldenrod
Sunburst Yellow
Dark Brown (Verithin)
Golden Brown (Verithin)
Light Grey (Verithin)
Dark Grey (Verithin)
White (Verithin)
Juniper Green (Lyra)
Olive Green
Limepeel
Light Green (Verithin)
Olive Green (Verithin)

Center

1 Layer Cool Grey 50%.

2 Layer Goldenrod.

3 Wash center with Bestine and a medium brush.

4 Layer Sunburst Yellow.

5 Wash center with Bestine and a medium brush.

6 Draw circles in darker area of center with Dark Brown (Verithin).

7 Draw circles in lighter area of center with Golden Brown (Verithin).

8 Lightly erase lighter area of center with kneaded eraser. Repeat step 7.

1

2

3

4

5

6

7

8

Stem and Leaf

10 Layer shadows with Cool Grey 70%. Layer Juniper Green (Lyra), Olive Green, Limepeel.

11 Lightly burnish with Cool Grey 10%, except darkest values. Lightly burnish with Olive Green, Limepeel, Light Green (Verithin). Sharpen edges with Olive Green (Verithin) or Light Green (Verithin).

Petals

9 Layer dark values with Dark Grey (Verithin), Light Grey (Verithin), Cool Grey 50%. Layer Cool Grey 20%, 10%. Wash with Bestine and a small brush. Lightly burnish with White (Verithin).

Snapdragon

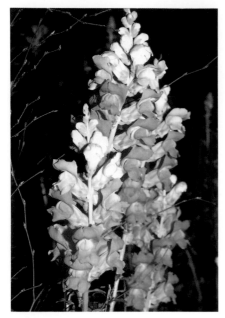

Reference photo

Color Palette

Henna
Rosy Beige
Process Red
Pink
Pink Rose
Deco Peach
Deco Pink
Goldenrod
Sunburst Yellow
White
Cream
French Grey 30%
French Grey 20%
French Grey 10%
Olive Green
Limepeel
Green Ochre (Pablo)
Olive Yellow (Pablo)

Petals

1 Layer shadows with Henna. Layer dark values with Rosy Beige. Layer Process Red (except lighter petals), Pink. Wash with Bestine and a medium-small brush.

2 Layer Pink Rose, Deco Peach, Deco Pink. Wash with Bestine and a medium-small brush, and lightly burnish this area with White.

3 Lightly burnish with Pink Rose, Deco Peach, Deco Pink.

4 Layer Sunburst Yellow. Wash with Bestine and a medium-small brush.

Buds

5 Layer French Grey 30%, 20%, 10%, Goldenrod.

6 Wash with Bestine and a medium-small brush.

7 Lightly layer with Limepeel.

8 Wash with Bestine and a medium-small brush.

9 Lightly burnish with Cream.

Stem and Leaves

10 Layer dark values with Olive Green. Layer Limepeel, Green Ochre (Pablo), Olive Yellow (Pablo).

11 Wash with Bestine and a small brush.

12 Lightly burnish with Cream.

13 Lightly burnish with Limepeel, Olive Yellow (Pablo).

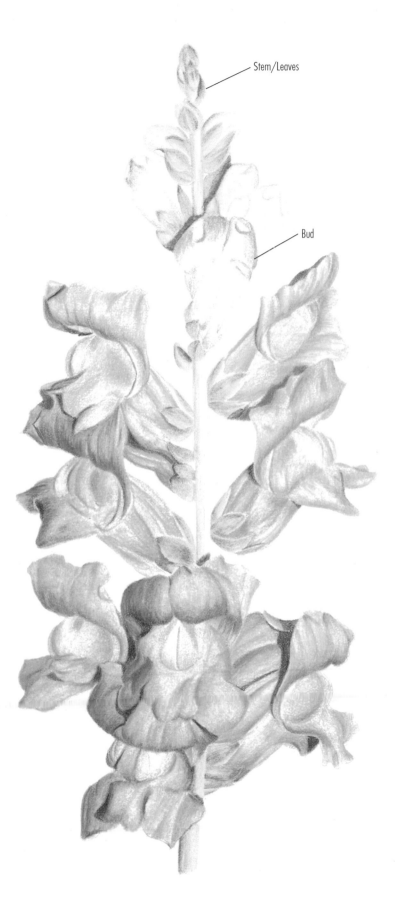

Stem/Leaves

Bud

Sunflower

Another View by **Judy McDonald**

Petals

1 Layer all with Tuscan Red, leaving highlights free of color.

2 Layer darkest values with Dark Purple and the shadows with Poppy Red.

3 To finish the petals, burnish with Canary Yellow. Lightly burnish shadows with Pale Vermilion. Burnish some highlights with Canary Yellow, leaving others free of color. Burnish edges with Mineral Orange, Poppy Red, Dark Purple.

Center

4 Layer outer ring with Burnt Ochre.

5 Lightly burnish inner circle with Indigo Blue, leaving gap concentric with outer ring free of color.

6 Lightly burnish gap described in step 5 with Yellow Chartreuse, dragging small amounts of color from outer and inner areas.

7 Layer entire center, except step 6, with varying amounts of Indigo Blue, Dark Purple, Poppy Red.

Leaves

8 Layer darkest values with Peacock Green, Indigo Blue.

9 Layer shadows with Violet. Layer highlight areas with Grass Green. Burnish edges with Spring Green.

10 Layer highlights with Light Green. Burnish veins and edges with Jasmine.

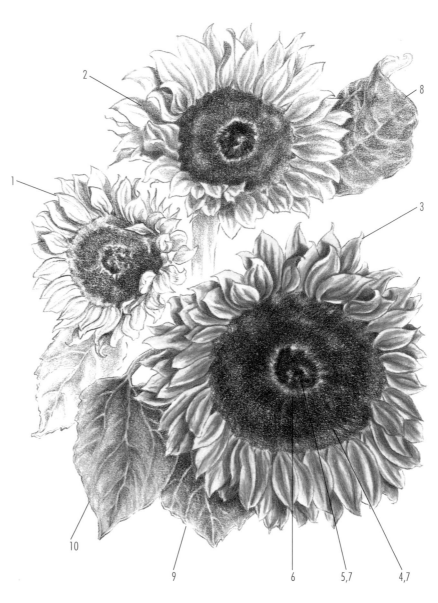

Color Palette

Tuscan Red	Yellow Chartreuse
Dark Purple	Peacock Green
Poppy Red	Violet
Canary Yellow	Grass Green
Pale Vermilion	Spring Green
Mineral Orange	Light Green
Burnt Ochre	Jasmine
Indigo Blue	

Trillium

Reference photo

Center and Petals

1 Layer dark values with Dark Grey (Verithin). Layer Cool Grey 50%, 20%, 10%. Smudge with a dry cotton swab. Wash with Bestine and a small brush.

2 Draw darker values with Golden Brown (Verithin). Burnish with Canary Yellow (Lyra).

3 Layer with Canary Yellow. Wash with Bestine and a small brush.

4 Draw darker values with Light Grey (Verithin). Wash with Bestine and a small brush, leaving some areas free of color.

5 Draw veins with Light Grey (Verithin), using lighter pressure at edge of petal.

Leaves

6 Layer Juniper Green (Lyra), Olive Black (Pablo), Olive Green, Limepeel. Lightly burnish with Cool Grey 10%. Burnish with Olive Green, Limepeel. Sharpen edges with Olive Green (Verithin).

Color Palette

Dark Grey (Verithin)
Light Grey (Verithin)
Cool Grey 50%
Cool Grey 20%
Cool Grey 10%
Golden Brown (Verithin)
Canary Yellow (Lyra)
Canary Yellow
Juniper Green (Lyra)
Olive Black (Pablo)
Olive Green
Limepeel
Olive Green (Verithin)

Tulip

Reference photo

Color Palette

Warm Grey 90%
Olive Green
Spanish Orange
Yellowed Orange
Canary Yellow (Lyra)
Crimson Red
Scarlet Lake
Poppy Red
White
Carmine Red (Verithin)
Juniper Green (Lyra)
French Grey 10%
Olive Green (Verithin)

Flower

1 Layer base of flower with Warm Grey 90%, Olive Green. Wash with Bestine and a small brush.

2 Layer Spanish Orange, Yellowed Orange, Canary Yellow (Lyra).

3 Wash with Bestine and a cotton swab.

4 Layer dark values with Crimson Red. Layer Scarlet Lake, Poppy Red.

5 Burnish with White.

6 Burnish with Scarlet Lake, Poppy Red.

7 Burnish edge of red areas with Canary Yellow (Lyra).

8 Layer variegations with Poppy Red. Sharpen variegations and edges with Carmine Red (Verithin).

Stem and Leaves

9 Layer dark values with Warm Grey 90%. Layer Juniper Green (Lyra), Olive Green.

10 Burnish with French Grey 10%.

11 Burnish with Juniper Green (Lyra), Olive Green. Sharpen edges with Olive Green (Verithin).

Tulip

1 Lightly layer shadows with Light Violet. Layer edges with Tuscan Red (Verithin). Layer Light Carmine, Dark Carmine.

2 Burnish with White (Prismacolor). Sharpen edges with Tuscan Red (Verithin). Layer Scarlet Lake, Rose Carmine. Burnish with White (Prismacolor).

3 Lightly layer shadows with Black Grape (Prismacolor). Layer Light Carmine, Dark Carmine, Scarlet Lake, Rose Carmine. Lightly layer secondary reflections with Pink Madder Lake. Sharpen edges with Tuscan Red (Verithin).

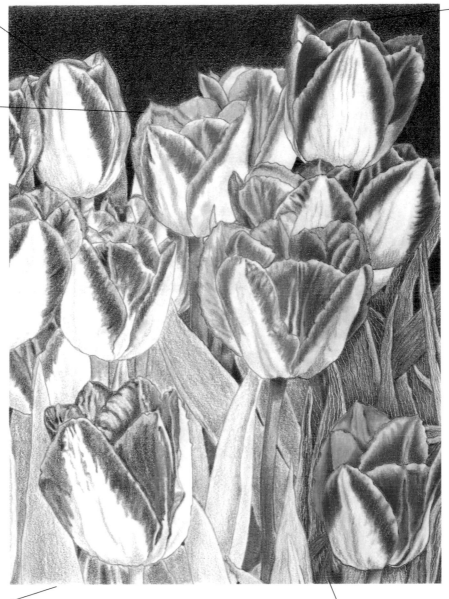

4 Layer darker values with Black Grape (Prismacolor), Indigo Blue (Prismacolor). Layer middle values with Juniper Green. Layer light values and stems with Grey Green.

5 Impress veins with a 7H graphite pencil and drafting or tracing paper. Lightly burnish with Cream. Lightly burnish shadows with Black Grape (Prismacolor). Lightly burnish with Indigo Blue (Prismacolor), Juniper Green, Cedar Green, Grey Green. Repeat burnishing as necessary beginning with Cream. Sharpen edges with Green (Verithin).

Color Palette

All colors are Lyra Rembrandt Polycolor unless otherwise noted.

Light Violet	Pink Madder Lake
Tuscan Red (Verithin)	Juniper Green
Light Carmine	Indigo Blue (Prismacolor)
Dark Carmine	Grey Green
White (Prismacolor)	Cedar Green
Scarlet Lake	Cream
Rose Carmine	Green (Verithin)
Black Grape (Prismacolor)	

Water Lily

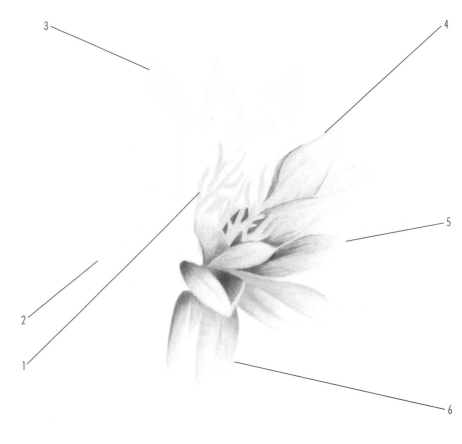

Color Palette

Spanish Orange
Sunburst Yellow
Deco Orange
Deco Peach
Scarlet Lake
Carmine Red
Blush
Rosy Beige
Pink Rose
White
French Grey 50%
Golden Brown (Verithin)
Goldenrod
Canary Yellow
Clay Rose
Tuscan Red
Henna
Carmine Red (Verithin)
Olive Green
Limepeel
Apple Green
Yellow Chartreuse
Light Green (Verithin)
Olive Green (Verithin)

Flower

1 Lightly layer stamen with Spanish Orange, Sunburst Yellow.

2 Lightly layer Spanish Orange, Sunburst Yellow. Smudge with a dry cotton swab. Wash with Bestine and a cotton swab.

3 Lightly layer Deco Orange, Deco Peach. Smudge with a dry cotton swab. Wash with Bestine and a cotton swab.

4 Layer Scarlet Lake, Carmine Red, Blush, Rosy Beige, Pink Rose.

5 Burnish with White.

6 Lightly burnish with Scarlet Lake, Carmine Red, Blush, Rosy Beige, Pink Rose.

7 Layer shadows on light pastel petals with French Grey 50%. Burnish with Clay Rose.

8 Burnish shadows in red areas with Tuscan Red or Henna.

9 Burnish stamen with Golden Brown (Verithin), Goldenrod, Canary Yellow.

Pad

10 Layer edges and center with Henna, Clay Rose. Wash with Bestine and a medium brush, using strokes emanating from/to center. Burnish with Henna, Clay Rose. Sharpen edges with Carmine Red (Verithin).

11 Layer shadows with Olive Green. Wash with Bestine and a small brush. Layer Limepeel, Apple Green, Yellow Chartreuse. Wash with Bestine and a medium brush.

12 Burnish shadows with Olive Green. Lightly burnish with Limepeel. Burnish with Yellow Chartreuse.

13 Draw veins with Henna. Burnish with Carmine Red (Verithin). Burnish vein highlights with White. Lightly burnish over with Yellow Chartreuse. Sharpen edges adjacent to petals with Light Green (Verithin) or Olive Green (Verithin).

Water Lily

Flower

1 Layer inside of petals with Pink Madder Lake (Derwent WS), Pink Rose, Pink, Deco Pink. Graduate as shown. Lightly burnish with Pink Madder Lake (Derwent WS). Burnish with colorless blender. Sharpen edges with Rose (Verithin) and Magenta (Verithin).

2 Outline petals with Primrose Yellow (Derwent WS). Burnish with colorless blender.

3 Layer outside of petal with Magenta (Derwent WS), Dark Purple. Burnish with colorless blender. Repeat as necessary.

Leaves

4 Layer May Green (Derwent WS).

5 Layer shadows with Bottle Green (Derwent WS). Layer inside with Cedar Green (Derwent WS).

6 Lightly burnish highlights with Primrose Yellow (Derwent WS). Repeat steps 4–6 as necessary.

7 Lightly burnish with Jade Green (Derwent WS), Aquamarine, Light Aqua.

Pad

8 Layer Emerald Green (Derwent WS). Burnish with colorless blender.

9 Layer randomly with Jade Green (Derwent WS), May Green (Derwent WS), Olive Green (Derwent WS), Kingfisher Blue (Derwent WS). Repeat as necessary.

Color Palette

Pink Madder Lake (Derwent WS)	May Green (Derwent WS)
Pink Rose	Bottle Green (Derwent WS)
Pink	Cedar Green (Derwent WS)
Deco Pink	Jade Green (Derwent WS)
Rose (Verithin)	Aquamarine
Magenta (Verithin)	Light Aqua
Primrose Yellow (Derwent WS)	Emerald Green (Derwent WS)
Magenta (Derwent WS)	Olive Green (Derwent WS)
Dark Purple	Kingfisher Blue (Derwent WS)

Zinnia

Center

1 Layer Sunburst Yellow. Wash with Bestine and a medium brush.

2 Layer Crimson Red, Dark Carmine (Lyra). Dab with Bestine and a medium brush, leaving areas of yellow showing through. Layer upper center area with Tuscan Red.

3 Burnish lower center area randomly with Tuscan Red. Dab with Bestine and a medium brush, leaving areas of yellow showing through.

4 Define yellow petals with Goldenrod. Burnish with Canary Yellow (Lyra).

Petals

5 Layer dark values with Tuscan Red. Layer Crimson Red, Dark Carmine (Lyra), Carmine Red.

6 Burnish with White.

7 Burnish with Crimson Red, Dark Carmine (Lyra), Carmine Red. Repeat as necessary. Sharpen edges with Carmine Red (Verithin).

Leaf and Stem

8 Layer Cool Grey 90%, Dark Green, Olive Green, Limepeel, Olive Yellow (Pablo).

9 Burnish with Cool Grey 10%. Burnish with Olive Green, Limepeel, Olive Yellow (Pablo). Repeat as necessary. Sharpen edges with Olive Green (Verithin).

Susan L. Brooks lives in the Chicago area and earned bachelor of arts degrees in fine art and art education at Ohio State University. After teaching junior high school and high school for a number of years, Susan decided to "get back to my art." She enrolled in a drawing course at a local college, where she discovered colored pencil. Having worked previously with charcoal, Susan was fascinated by the thought of using colored pencil. Susan's uniquely stylized paintings appear in *The Best of Colored Pencil* 3 (Rockport) and have been exhibited in the 1995 CPSA International Colored Pencil Exhibition and the Crayon du Colour Exhibit at the Barrington Arts Council Gallery in Barrington, Illinois. Susan is the president of the Chicago District Chapter of the CPSA.

Edna Henry is a native of Oregon and a graduate of Willamette University in Salem, Oregon. Edna loved to draw and paint as a small child, but had no formal art instruction until college when she took art classes while pursuing other studies. While involved with oil painting and watercolor, she struggled to overcome her realistic bent which seemed to be unacceptable in an art world committed to "less is more." The struggle ended when she discovered colored pencils that seemed to insist that Edna do her realistic thing. She studied colored pencil, among other mediums, with Bet Borgeson, Bernard Poulin and Gary Greene. Her work has appeared in *The Best of Colored Pencil* 2 (Rockport) and *Creative Colored Pencil: The Step-by-Step Guide and Showcase* (Rockport) and has been exhibited in such prestigious events as the 1993 and 1994 CPSA International Colored Pencil Exhibitions.

Kristy Ann Kutch lives in Michigan City, Indiana, and received both bachelor's and master's degrees in elementary education from Purdue University. Urged into taking watercolor classes, Kristy eventually found her artistic niche in a colored-pencil drawing class. Colored pencil suited her lifestyle as an aspiring artist working during her young children's nap times! Featured in *The Best of Colored Pencil* (Rockport) and *Creative Colored Pencil: The Step-by-Step Guide and Showcase* (Rockport), Kristy is also a Charter Member of the CPSA and has taught colored pencil since 1991. Her favorite subjects include the Indiana Dunes and the Lake Michigan waterfront.

Calla Lilies 14½" x 18½" (37cm x 47cm), Susan L. Brooks

Summer Song 11" x 15" (28cm x 38cm), Edna Henry

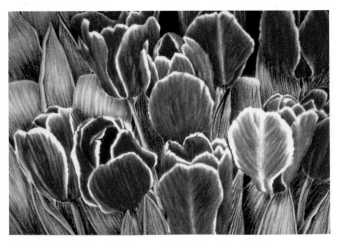

Blazing Tulips 11" x 14" (28cm x 36cm), Kristy Ann Kutch

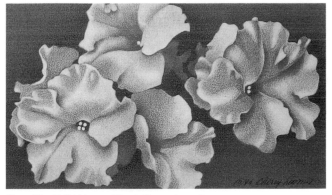

Flora 5" × 7¾" (13cm × 20cm), Sherry Loomis

Sherry Loomis received her bachelor of arts degree with honors at California Polytechnic State University, and she studied art at California State University at Long Beach and at San Francisco State University. She is a Charter Member of the CPSA and an Associate Member of the Society of Children's Book Writers and Illustrators. Her beautiful, delicately layered paintings have achieved recognition in international, national and local exhibitions, such as the 1993 CPSA International Colored Pencil Exhibition and the Realism '94 Exhibition. Sherry is featured in *Creative Colored Pencil: The Step-by-Step Guide and Showcase* (Rockport) and *The Best of Colored Pencil 2* (Rockport). Sherry lives in Arroyo Grande, California.

Judy McDonald is a native of Los Angeles, California, where she works as a professional artist and workshop instructor. Her delicate, sensitive images of flowers, children, antique dolls and clowns have appeared in juried exhibitions and gallery shows and hang in both public and private collections. Judy's choice of colored pencil as her medium goes back to the time when there were no "how-to" books available and when there were no classes offered in colored pencil. As a result, Judy, like most colored-pencil artists, made the medium perform in her own unique style and has become an expert on the subject, maintaining a busy schedule of lectures, demonstrations and workshops. Judy's work has appeared in *The Best of Colored Pencil* (Rockport) and *Creative Colored Pencil: The Step-by-Step Guide and Showcase* (Rockport).

Terry Sciko, CPSA, is a native of Cleveland, Ohio, and completed her formal education at Cleveland State University with a bachelor of fine arts degree. Lilies, roses, mums and wildflowers, whether in her garden or in her artwork, show the challenge that Terry sees in flowers because of the ever changing variety of subjects, colors and shapes. Terry has worked in ink, graphite and stone lithography and has studied graphic design and color theory. She, like most colored-pencil artists, is self-taught, preferring colored pencil because detail can be shown as in nature. Terry's honors include being a Signature Member in the CPSA, having works appear in the 1993, 1994 and 1995 CPSA International Colored Pencil Exhibitions, and being a finalist in the 1993 *Artist's Magazine* competition. Her work appears in *The Best of Colored Pencil 2* and *3* (Rockport).

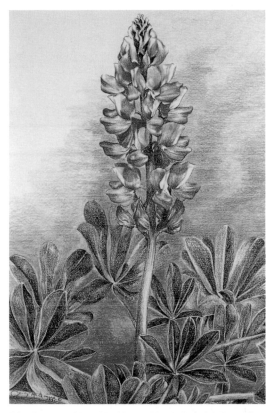

Blue Lupine 14" × 12" (36cm × 30cm), Judy McDonald

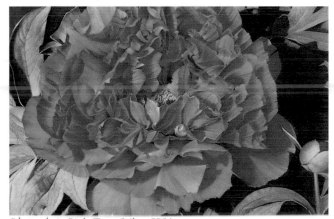

Rhapsody in Pink, Terry Sciko, CPSA

Index